IMAGES
of America

NARRAGANSETT
BREWING COMPANY

NARRAGANSETT BREWERY,

Corner Fountain and Jackson Streets.

ADVICE TO ALE VENDERS.

I offer the public something long sought for—Ale *good* and *cheap*. My XX Ale, at $8 per barrel, is warranted as good as any other in market at $10; and my XXX, at $10, I warrant to be the *best "present use"* Ale to be found. It is made of the best English, German and Canada Barley, of my own malting, and the choicest hops, and is therefore a pure and healthy beverage. The barrels are warranted to hold as much as any others in the market. I challenge any of my customers in Rhode Island, New York, Boston, or elsewhere, to say, in justice, they had a barrel of sour Ale from me this year. How many *other* brewers selling Ale here can say the same in truth? The public are invited to test the veracity of the above asser tions by a trial of my Ale, and an examination of the materials from which it is made.

I also purpose making a Hop Beer for persons having no license, and keeping it constantly on hand for them, wishing my customers and friends to do business within the limits of the law. JOHN BLIGH.

Providence Oct. 16, 1869. · 1yd2dp

This advertisement for the Narragansett Brewery was in the *Providence Morning Herald*, dated November 5, 1869. This may be the earliest known reference of the Narragansett Brewing Company, or it may be an early name variation for one of Narragansett's chief competitors in Rhode Island, the James Hanley Brewing Company, which operated on the corner of Jackson and Fountain Streets in Providence until the mid-1950s. Narragansett would later buy out the Hanley brand upon the closure of this brewery. (Courtesy of Ed and Greg Theberge collection.)

On the cover: Please see page 46. (Courtesy of Ed and Greg Theberge collection.)

2008

To Docter Jorden Sheff

IMAGES
of America

NARRAGANSETT
BREWING COMPANY

*Hope you enjoy these
N. B. C. memories!*

Hazel B. Turley

Hazel B. Turley

Emmet E Tursley.

ARCADIA
PUBLISHING

Published by Arcadia Publishing
Charleston SC, Chicago IL, Portsmouth NH, San Francisco CA

Printed in the United States of America

Library of Congress Catalog Card Number: 2007924460

For all general information contact Arcadia Publishing at:
Telephone 843-853-2070
Fax 843-853-0044
E-mail sales@arcadiapublishing.com
For customer service and orders:
Toll-Free 1-888-313-2665

Visit us on the Internet at www.arcadiapublishing.com

CONTENTS

SPECIAL THANKS

The author wishes to thank the following individuals who donated history, personal experiences, photographs, memorabilia, and anecdotes that were used in preparing this history of the Narragansett Brewing Company:

Edmund Dejesus	Beer Can Collection
Clem Gormley	Warehouse Worker
Nancy Haley Lyle	Daughter of Jack Haley (Advertising)
Gale Curren	Daughter of Charles Miller
Harold Henn	Son of Otto Henn (Brewmaster)
Peter Clarke	Red Sox Liaison
Martin Odsen	Union Representative
Guy Lister	Tour Guide/Brew Bus Driver
Vivian Brunelle	Hi Neighbor Girl
Thomas Kelly	Kettle Room Worker
William Anderson	Brewmaster
Randall Blakesee	Brewmaster
Robert Skinkle	Laboratory/Quality Control
Jaquie Carrier	Laboratory/ Quality Control
Francis Dempsey	Maintenance
Raymond Dempsey	Maintenance
William Devereaux	Sales/Events
Robert Burgess	Sales
Matthew Kieron	Signs
Ralph Stuart	Orchestra Leader/Television Show
Jim Nolan	Sales/Public Relations
J. Joseph Garrahy	Sales
Joe Hanley	Sales
Vincent Garrahy	Government Cellar Worker
Betty M. Thomaselli	Daughter of Bottle Inspector
George Tantimonico	Baseball Team Member
David Haffenreffer	Advertising Staff Member
Robert Webb	Sales
Jim Kelly	Brewery Worker
Jim McCann	Brewery Worker
Harold Nelson	Bottling Shop

INTRODUCTION

In 1890, a group of German American descendants got together with talent, time, and money ($150,000) and opened a brewery in the Arlington section of Cranston. On April 8, 1891, an act was passed in the Rhode Island General Assembly to incorporate this joint venture into the Narragansett Brewing Company, part of an industry that would become a giant in New England in the 20th century. One of the founders was a member of the yacht club in Edgewood and an avid sailor, so the group chose to name its brewery venture after Narragansett Bay.

Sadly, this business would not survive to observe a centennial celebration, but rather, in the late 1990s, it lay in ruins, its fate unknown, as over 40 acres of land and buildings remained neglected and forgotten.

This book intends to remember the golden years of the Narragansett Brewery, when it was number one in beer sales in New England; a proud sponsor of baseball and football teams, along with numerous community events; and served as a family to its many employees. This history is the story of these people, mostly unskilled laborers and some recent World War II veterans, who deeply respected the company and helped make "Hi—Neighbor, Have a 'Gansett" the greeting of the New England countryside.

This history will focus on pictorial remembrances of former employees. The formative early history and the rebirth of the company bookend these memories. With this reminiscence about the Narragansett Brewing Company, the ruins will give way to a memory of a glorious complex that produced a wonderful product—Narragansett beer.

Upon entering the brewery grounds, a huge statue of Gambrinus, a mythical Flemish king said to be the inventor of beer, greets all with a raised cup in a gesture of welcoming and hospitality. Hospitality was the main ingredient of the magic formula that made visits to the Narragansett Brewing Company a wonderful experience for the friends, customers, and organizations that came to observe the brewing process and to sample the beer.

In March 1948, Vice Pres. Carl W. Haffenreffer, as one of the principal co-owners, issued a memorandum about the Hospitality Room. It was a place where visitors were brought after their tours to enjoy some beer, and he stressed how important it was for guests to feel welcomed into the world of the Narragansett Brewing Company.

As he stated, back in those days, "No industry relies more upon the good will, neighborliness, and friendship of the public than does the brewing business." This philosophy and guidance would continue for many decades and see the Narragansett Brewing Company revel in an era of unparalleled success and goodwill.

ACKNOWLEDGMENTS

The author wishes to acknowledge those with special skills and creative ideas in producing this book about the Narragansett Brewing Company: Dawn Robertson, Arcadia Publishing; Greg and Ed Theberge, Narragansett Brewing Company memorabilia; Mark Hellendrung, Narragansett Brewing Company owner; Emmet E. Turley, photograph scanning; and Kevin E. Turley, photograph prints.

One

THE EARLIEST YEARS
1890–1915

From its inception in the late 19th century, the Narragansett Brewing Company demonstrated progressive and steady growth. At this time, Rhode Island and the city of Cranston, where the brewery was located, were experiencing a surge of population growth. A rainbow of immigrants enjoyed the pleasure of drinking beer, and the Germans were experts at brewing. Besides the early production of lager and porter, artificial ice was also a product in great demand. Four tons were produced daily from nine artesian wells on the site. By the 20th century, 25 tons of ice were being delivered to over 1,500 customers. The brewery added greatly to the state's growing economy by employing about 150 people in various jobs as coopers, blacksmiths for the 70 horses used in delivering the kegs, and railroad men used to operate the two refrigerator cars, as well as the bottling shop crew, brewery workers, and brewmasters. Early in the 20th century, the quality of its products, as well as the increasing demand, necessitated equipment and plant development. Keeping abreast of advances in the science of brewing helped the owners to create a modern and hygienic bottling company. In 1910, an advertisement in the trade journal revealed that the brewing company received the distinction of being described as "excellent" with respect to conditions of cleanliness and sanitation. Celebrating its 25th anniversary on December 29, 1915, newspaper accounts reported that the Narragansett Brewing Company covered 42 acres of land at the Providence and Cranston city lines, on which were 30 buildings, including the horse stable, a garage for 50 wagons, and motor trucks used in local deliveries. It also possessed three refrigerating machines, plus an ice pond and icehouse, and, by then, three refrigerator cars. More bottles were now being used, and the advertisements in the trade journals displayed several different sized bottles. Their labels said, "The Famous Narragansett, Made on Honor, Sold on Merit,—Lager, Ale, Malt Extract," and underneath it read, "Especially put up for export to Southern Ports." This brewery was no longer just local, it was countrywide. Early reports state that in the first year the company brewed 28,000 barrels. In 10 years, the consumption was strikingly increased to the amount of over 114,000 barrels in 1901. By 1909, that number had almost doubled, and upon celebration of the first 20 years, an astounding record 225,000 barrels of Narragansett beer were perfectly brewed.

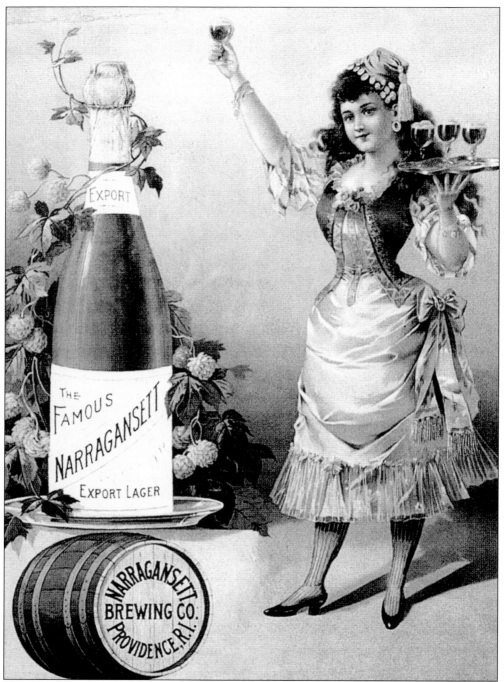

Many early advertisements for the brewery featured lovely ladies dressed in fancy garments, posing with items such as bottles and kegs. Here a toast, around 1895, is being offered with a glass of Narragansett Export Lager. Note the fact that the bottle is corked and wrapped; it does not have a bottle cap. Bottles such as these required the use of a corkscrew and were opened in the same manner as opening a bottle of wine. (Courtesy of Ed and Greg Theberge collection.)

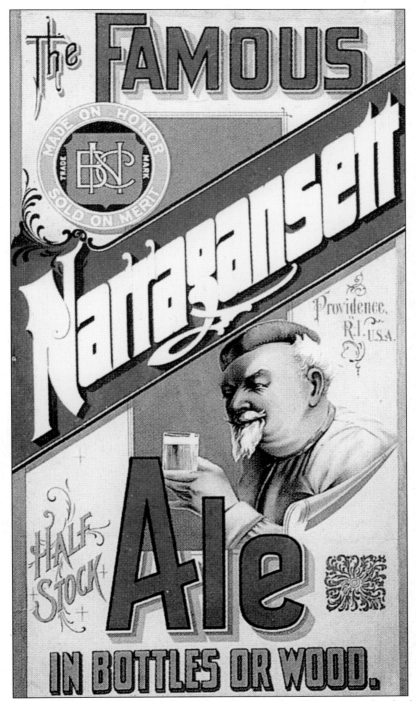

This striking 1895 lithograph is one of the earliest known advertising pieces for the brewery. It promotes Narragansett Half Stock Ale, which came in either bottles or wood (draft). Prior to Prohibition in 1920, the official address for the brewery was Providence. (Courtesy of Ed and Greg Theberge collection.)

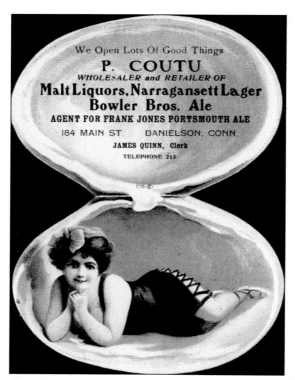

P. Coutu, wholesaler and distributor of malt liquor and Narragansett Lager, distributed these early trade cards sometime during the first two decades of the 20th century. (Courtesy of Ed and Greg Theberge collection.)

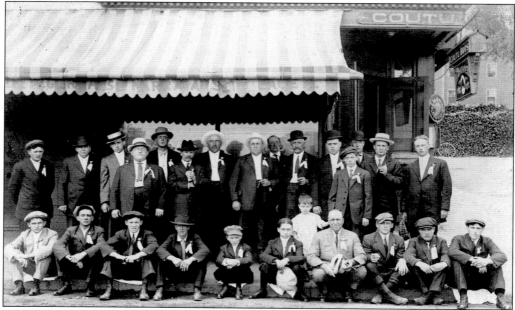

A group of gentlemen pose for this picture taken outside Coutu's bar, which advertises Narragansett Lager on its awning, around 1910, probably in Connecticut. Note the whiskey sign and Hand Brewing Company reversed on glass round sign over the front door. The Hand Brewing Company was one of Narragansett's competitors during the early part of the 20th century. (Courtesy of Ed and Greg Theberge collection.)

This 1902 two-inch paper calendar, put out for a New Hampshire distributor, promotes and praises the best of Narragansett Lager and Ale. (Courtesy of Ed and Greg Theberge collection.)

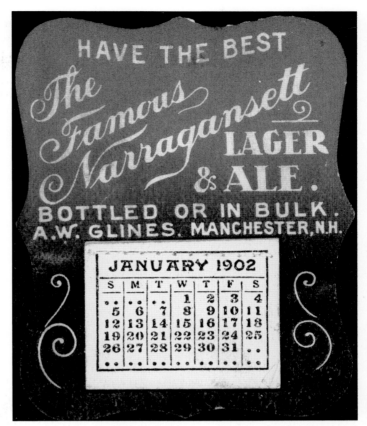

In the 19th and early 20th centuries, horse-drawn wagons delivered barrels of beer to taverns and other local establishments. Along with others like it, this Narragansett hitch, with its horses and wagon, was housed in stalls on the premises. (Courtesy of Ed and Greg Theberge collection.)

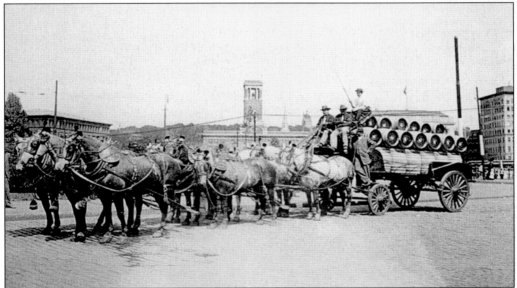

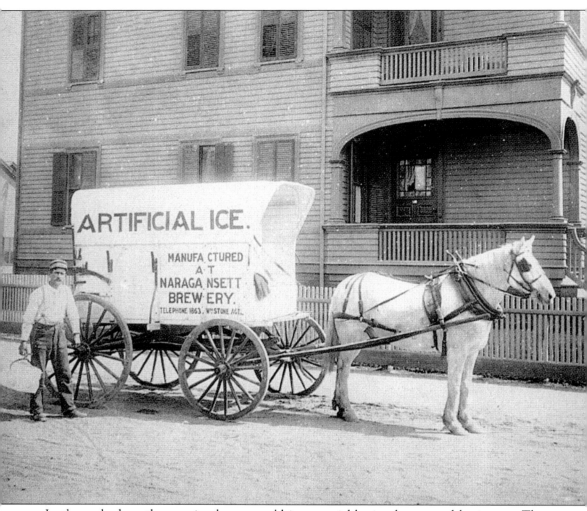

In the early days, the growing brewery sold ice to neighboring homes and businesses. These horse-drawn wagons were the first vehicles to be used to make the deliveries. By the time of Prohibition days, the brewery would sell ice to 50,000 customers. (Courtesy of Ed and Greg Theberge collection.)

This late-19th-century corkscrew was used to open bottles of Narragansett prior to the invention of the bottle cap. (Courtesy of Ed and Greg Theberge collection.)

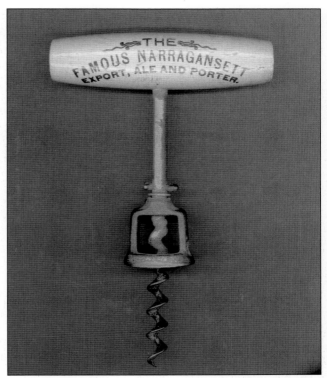

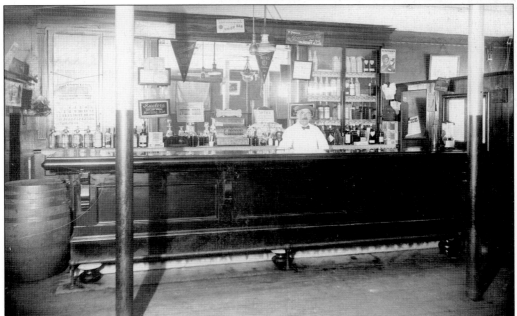

This is a photograph from the first decade of the 20th century, displaying a typical barroom interior featuring Narragansett Brewing Company lithographs, reversed on glass signs, and felt pennants. Note the spittoon on the floor and the bartender ready to take an order. (Courtesy of Ed and Greg Theberge collection.)

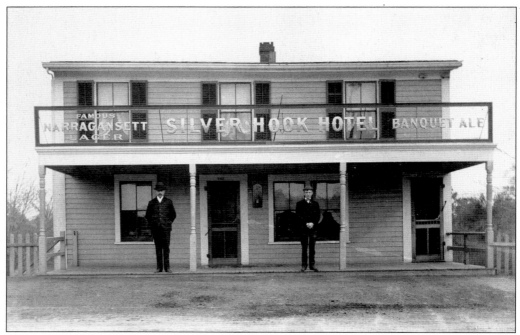

The facade of the Silver Hook Hotel, advertising Narragansett Lager on the left and Banquet Ale on the right, is shown in this photograph taken between 1900 and 1910. (Courtesy of Ed and Greg Theberge collection.)

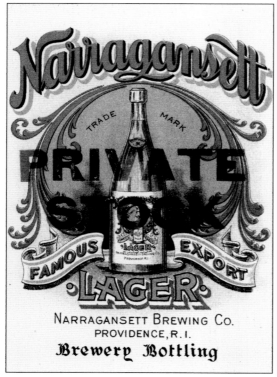

Shown here is a *c.* 1900 label for Narragansett Lager featuring a corked bottle. (Courtesy of Ed and Greg Theberge collection.)

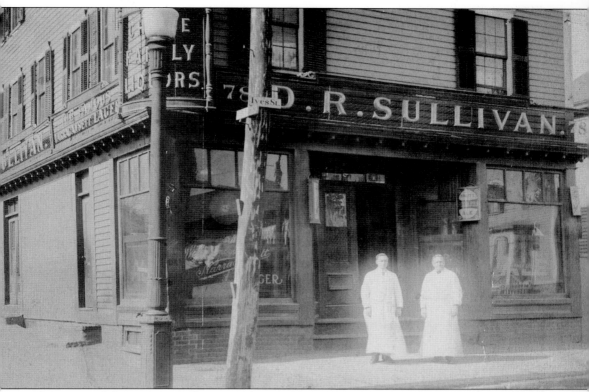

This postcard shows D. R. Sullivan's package store on Ives Street, probably in Providence. It is advertising Narragansett Banquet Ale in a large reversed on glass sign in the front window. Note the two employees, or proprietors, dressed in their white gowns in the forefront. Neon signs, signs of bikini-clad girls, and other flashy store advertisements would not come into being until many years in the future. (Courtesy of Ed and Greg Theberge collection.)

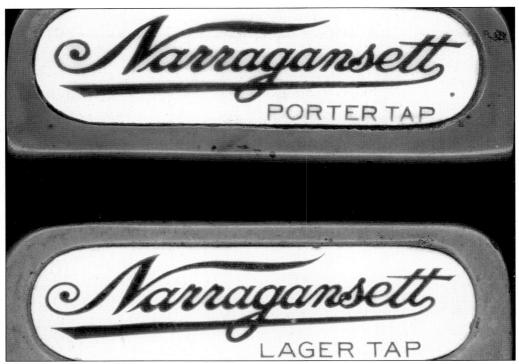

These c. 1910 brass and porcelain tap markers were mounted on the bar space in front of the individual draft stanchions so that thirsty patrons could see what was on tap. (Courtesy of Ed and Greg Theberge collection.)

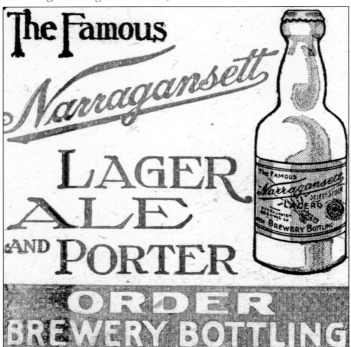

This is a pre-Prohibition coaster for Narragansett Lager, Ale, and Porter. This is the earliest known variation of a beer coaster for the Narragansett Brewing Company. It is a fun example of an early advertising initiative, in which every time a glass was lifted the person read "order." Most folks did! (Courtesy of Ed and Greg Theberge collection.)

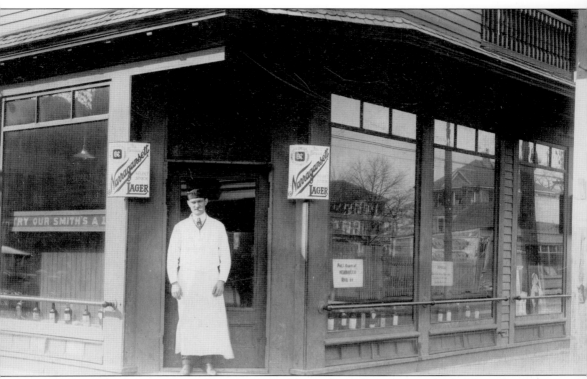

Here is a public house exterior featuring its publican dressed in a white frock. Note the two porcelain "corner" signs advertising Narragansett Select Stock Lager around 1910. (Courtesy of Ed and Greg Theberge collection.)

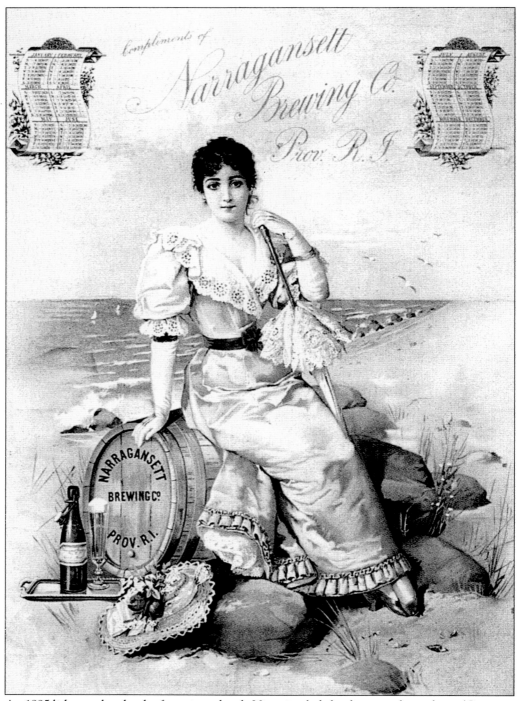

An 1895 lithograph calendar featuring a lovely Victorian lady by the sea is shown here. (Courtesy of Ed and Greg Theberge collection.)

This stoneware Narragansett Brewing Company matchstick holder was given away as a souvenir for the Fraternal Order of Eagles's second annual field day held in Providence on August 3, 1905. (Courtesy of Ed and Greg Theberge collection.)

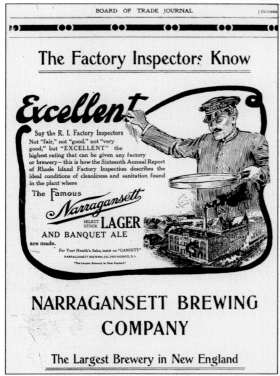

This is an advertisement about Narragansett Brewery Company in an October 1910 *Board of Trade Journal*. It was given an "excellent" review by the Rhode Island Factory Inspection. (Courtesy of Providence Public Library.)

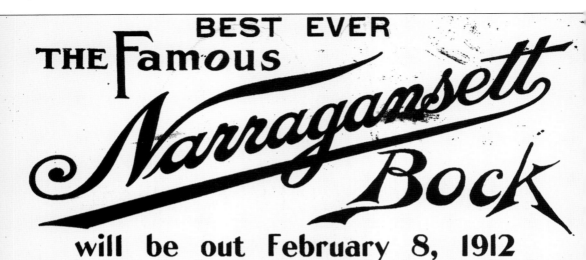

BEST EVER

THE Famous

Narragansett Bock

will be out February 8, 1912

Please order early and insure prompt delivery

NARRAGANSETT · BREWING CO.

PROVIDENCE, R. I.

This 1912 postcard is advertising the upcoming release of the "Best Ever" Narragansett Bock Beer. (Courtesy of Ed and Greg Theberge collection.)

Two

THE PROHIBITION YEARS
1916–1933

Once again, history books tell the story of the next eras—World War I and Prohibition. World War I would see some of the brewery workers go off to fight battles in foreign countries, some to countries they or their parents had left to immigrate to the United States of America. Wars cause serious rationing, so much of the early success of the previous years was cut back. However, within this very country and in every state, there was a battle being fought that would shut down the production of beer for many years. The Narragansett Brewing Company would be one of the victims. During the first two decades of the 20th century in the United States of America, a revival of Prohibition efforts began, mostly in the South and West. So-called anti-saloon leagues increased in numbers. National Prohibition was adopted in this country with the ratification of the Eighteenth Amendment to the Constitution, on January 16, 1919. It was called the Volstead Act, and it prohibited the consumption of alcohol in the United States. This period lasted over 14 years until ending on December 5, 1933. There were serious economic effects on the breweries. Many of the workers were let go and had to find jobs in new trades elsewhere. Some of the Narragansett workers found work in neighboring mills. However, this also was the time of the Great Depression, so the lifestyles of most Rhode Islanders changed drastically. The farmers who supplied the special ingredients lost valuable markets. Other industries, like transportation, restaurants, advertising, and so on, all underwent similar declines. Alas, Uncle Sam and the U.S. government lost as well, as there were very few taxes to be obtained. Narragansett Brewing Company survived during this period by continuing to operate its large artificial ice plant, enabling it to provide tons of ice daily to its private customers. A special small amount of beer was produced and available by doctors' prescriptions for people who needed to drink beer for health purposes. It also sold a product called near beer, made from malt, which appealed to former beer-drinking customers. Neighborhood boys of that time reported that several types of soda were also made, and if they happened to wander onto the brewery property, they were given a soda and told to be on their way.

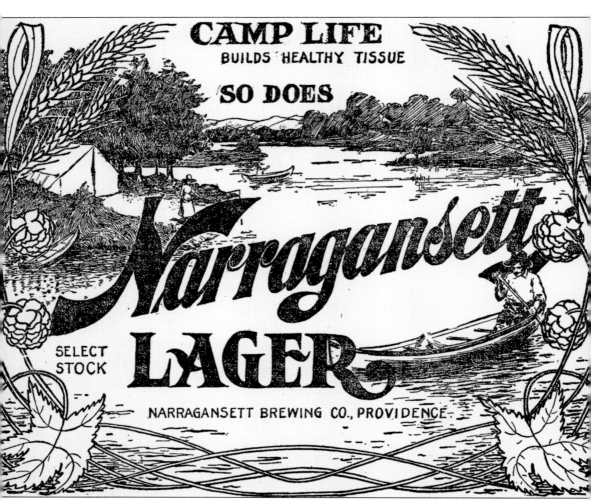

This newspaper advertisement promoting camp life is for the Narragansett Brewing Company before Prohibition. Several of the earlier owners were avid sailors, so many of the advertisements depicted water scenes and healthy living. (Courtesy of Ed and Greg Theberge collection.)

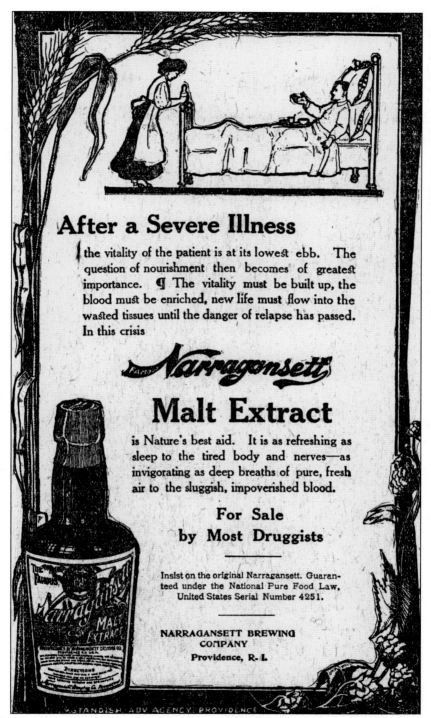

A pre-Prohibition newspaper advertisement for Narragansett Malt Extract is featured here. During the dark days of Prohibition, Narragansett continued to produce this product, in addition to ice and a soda line, for its survival. (Courtesy of Ed and Greg Theberge collection.)

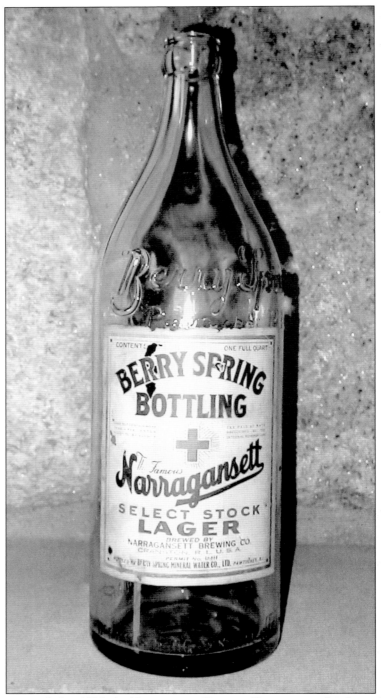

After Prohibition ended in 1933, the Narragansett Brewing Company used independent bottling companies to distribute its product as the need arose. This bottle, made just after the repeal of Prohibiton, is from the Berry Spring Bottling Company in Pawtucket. (Courtesy of Ed and Greg Theberge collection.)

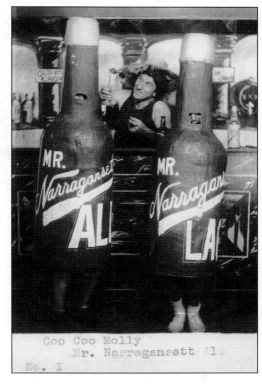

Coo Coo Molly, with Mr. Narragansett
Ale and Mr. Narragansett Lager, was
featured on some unique postcards. These
were used for promotional purposes during
the 1930s. (Courtesy of Ed and Greg
Theberge collection.)

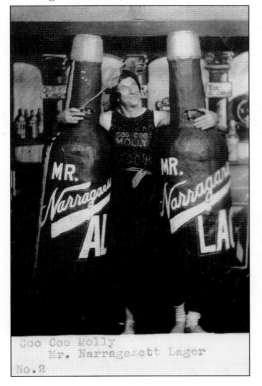

A very unusual store around 1935 features a diverse assortment of goods such as men's ties, Mickey Mouse novelties, and, in addition to other beers, Narragansett Ale. (Courtesy of Ed and Greg Theberge collection.)

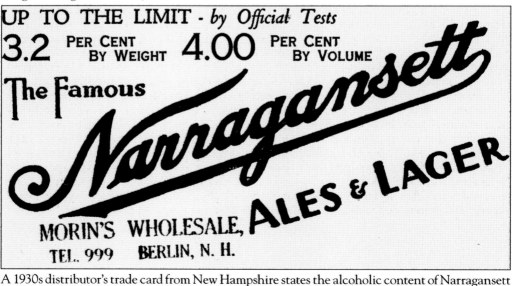

UP TO THE LIMIT - *by Official Tests*

3.2 PER CENT BY WEIGHT **4.00** PER CENT BY VOLUME

The Famous *Narragansett*

MORIN'S WHOLESALE, ALES & LAGER

TEL. 999 BERLIN, N. H.

A 1930s distributor's trade card from New Hampshire states the alcoholic content of Narragansett beer. At this time Narragansett enjoyed being the number one beer in New England. (Courtesy of Ed and Greg Theberge collection.)

Three

THE REVIVAL ERA
1933–1941

Following the repeal of Prohibition in 1933, new owners, the Rudolph F. Haffenreffer family from Fall River, Massachusetts, purchased and took over the operations of the Narragansett Brewing Company. They revived earlier enhancements to increase the production capabilities as well as the quality of Narragansett labeled beers. As stated previously, Prohibition had impacted most of the previous customers, who had waited a long time for a cool Narragansett beer. The Haffenreffer families were in the beer industry for many years, both in their former homeland of Germany and in Boston. By way of a brief history, one can understand how the Haffenreffers were able to so quickly revive the Narragansett Brewing Company and become the first brewery in the nation to produce and deliver beer after the repeal of Prohibition. Between 1868 and 1871, Rudolph Sr. arrived from Germany to Boston as an experienced maltster and barrel maker. This experience helped him to establish Boylston Lager Beer Company, which later became Haffenreffer and Company. For almost 25 years, the family resided in Boston, where Rudolph Jr. was born in 1874. Twenty years later, he attended U.S. Brewer's Academy and Massachusetts Institute of Technology, to follow in his father's footsteps. In 1895, the family moved on to Fall River, Massachusetts, and established the Old Colony Brewing Company. This success led Rudolph Haffenreffer Jr. to acquire the Narragansett Brewing Company in 1931. He was president until 1954. He had two sons, and they would help their father guide the Narragansett Brewing Company to success once again. Some of the former workers were hired back, and other experienced workers were sought and quickly found. Otto Henn returned as brewmaster, and he remained there until the mid-1950s, when he was replaced by another German by the name of John Strauss. In 1936, William (Bill) Considine Sr. was hired to develop a sales team to promote the return to the business of selling beer, not just beer, but Narragansett Ale and Lager beer. At that time, 12 ladies graced the brewery as secretaries, along with laboratory and health personnel. Also during this period, John (Jack) Haley became advertising manager and created the famous "Hi—Neighbor, Have a 'Gansett!" slogan that would be found in advertisements, on signs, and in a jingle sung around the region up through the 1960s. This was a team that was well prepared and determined to deliver a quality product for many years to come.

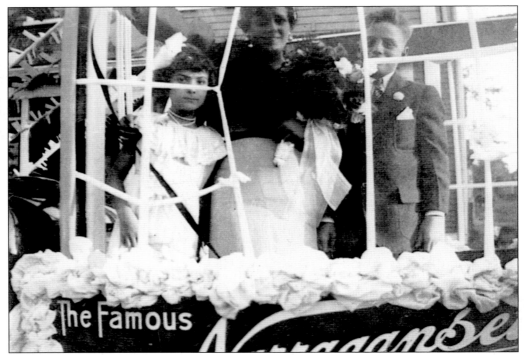

In October 1935, Grace Cineri (center), age 16, was chosen as Miss Narragansett Brewery. In this photograph of the parade, her sister, Marie, age 10, is with her. The young man is unknown. Grace went on to marry a company employee. (Courtesy of Gina Manfredi.)

During the 1930s and 1940s, these foam scrapers were used to wipe the foam from the top of a glass of draft beer. (Courtesy of Ed and Greg Theberge collection.)

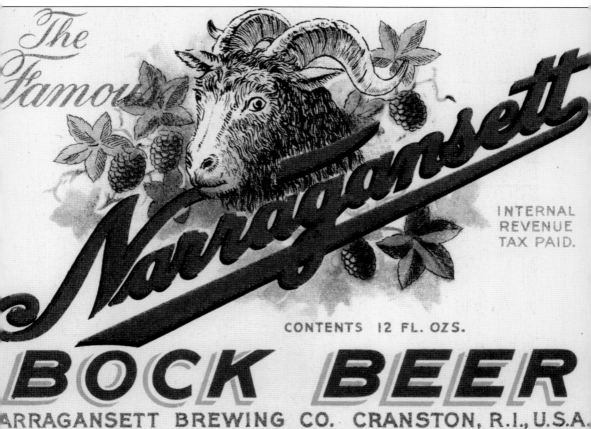

Bock beer was traditionally brewed during the winter for early springtime release. Legend has it that this type of beer originated in Germany (Einbeck). A mountain goat has always been associated with bock beer, hence this label from the late 1930s. (Courtesy of Ed and Greg Theberge collection.)

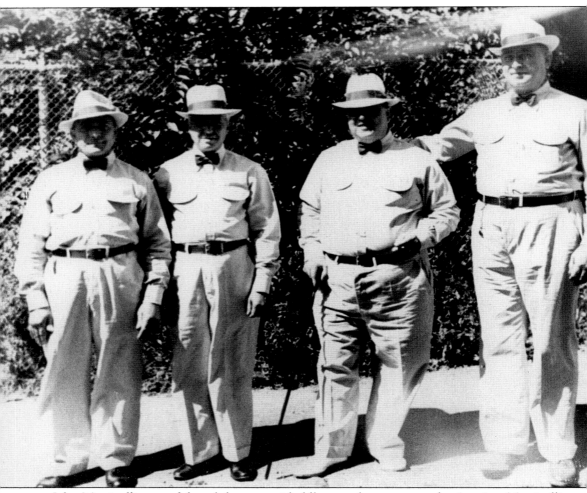

John Martinelli, second from left, poses with fellow employees at a workers' outing. Martinelli worked at the brewery before and after Prohibition. He was one of many truly loyal workers. (Courtesy of Betty M. Thomaselli.)

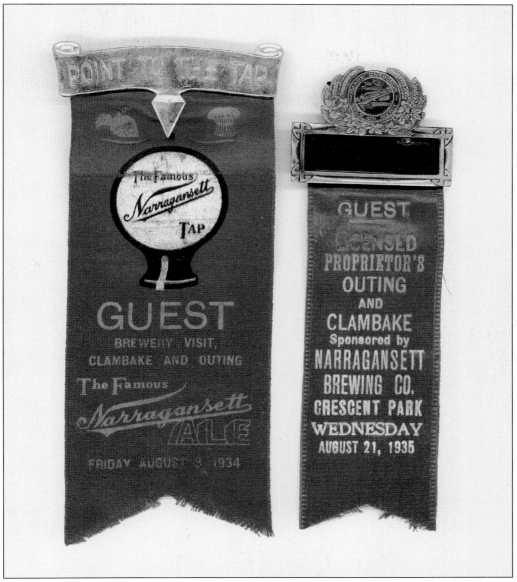

Pictured here are clambake guest ribbons from 1934 and 1935. (Courtesy of Ed and Greg Theberge collection.)

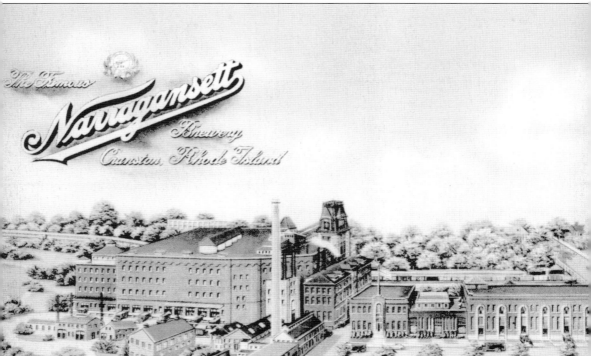

This *c.* 1935 linen postcard depicts the Narragansett Brewing Company in an idyllic, although somewhat less than accurate, industrial setting. After Prohibition, the official location was in Cranston. (Courtesy of Ed and Greg Theberge collection.)

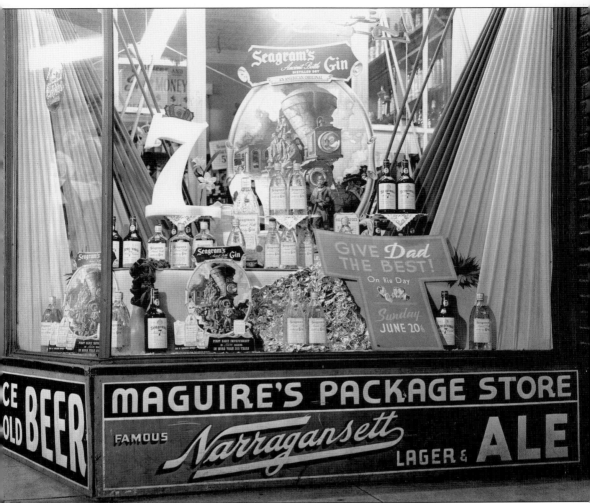

A *c.* 1950–1955 photograph of Maguire's Package Store displays a classic Narragansett sign. Brewery and liquor advertisers often dressed storefront windows to promote their products. (Courtesy of Ed and Greg Theberge collection.)

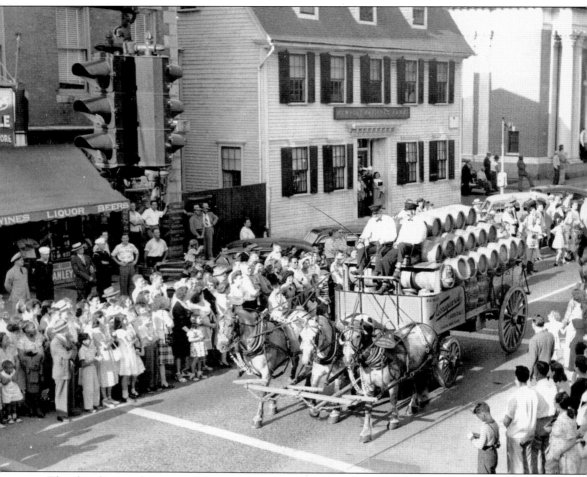

This lovely parade scene shows three horses pulling a wagon full of kegs. In the early days prior to Prohibition, beer was distributed in wagons such as these. By the 1940s, when this photograph was taken, these hitches were used for promotional events. (Courtesy of Ed and Greg Theberge collection.)

Four

THE WORLD WAR II ERA
1940–1949

The next era brought a serious setback with the United States' involvement in World War II, as many of the brewery workers went off to serve their country. Inside the brewery there was a picture of a battleship and airplanes and all the names of all the Narragansett workers who were away in the various services. Rationing was part of the lifestyle during those years, and the brewery also felt the shortages, as grain and other ingredients were less available. The beer was rationed as well, and much of it, in special khaki-colored labels, was shipped overseas to the men in service. One older retired naval officer remembered when, on tour in the South Pacific, they traveled in small boats to an atoll for four hours of "R&R." During that time there was nothing to do but sit around and drink all the Narragansett beer one wanted. Returning to the ship via the nets proved to be one of the worst battles they ever encountered during the war. After the war was over, the Narragansett Brewing Company decided to become the major brewer in New England. Advertising focused on lager beer, and the advent of television in 1948 became a major vehicle for increased sales. Close affiliation to the Boston Red Sox in nearby Boston also helped, and the brewery stole the lead with aggressive marketing. The company enlisted the patronage of Curt Gowdy, announcer for the Red Sox team, and Irene Hennessy, one of the lovely "Hi Neighbor Girls" who escorted visitors on tours of the brewery and did many promotional events. Several years of extremely popular commercials helped boost sales and featured the voices of Mike Nichols and Elaine May. Those invited to a tour of the brewery were treated as honored guests and ended in the elegant Hospitality Room, where Narragansett beer flowed freely for all. Many visitors and customers found themselves riding on the Brew Bus to baseball games, football games, festive events, country clubs, and golf meets. In March 1948, Carl W. Haffenreffer, then vice president, presented "A Restatement of Narragansett's Friendly Neighbor Policy," declaring that "the company spends hundreds of thousands of dollars a year to create good will and friendship, and to convince the public that Narragansett is a high quality product, 'Made on Honor and Sold on Merit,' and that people who work at the brewery are 'nice people.'"

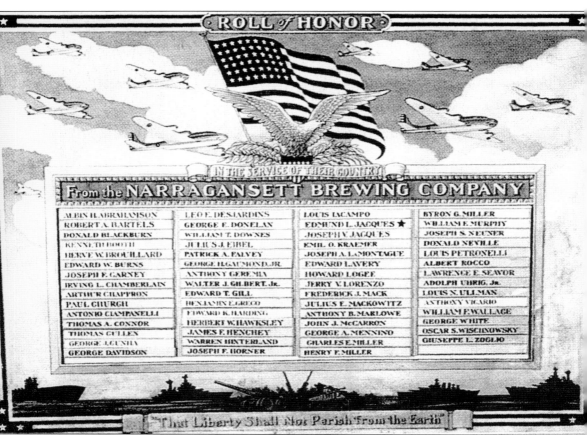

ROLL of HONOR

IN THE SERVICE OF THEIR COUNTRY

From the NARRAGANSETT BREWING COMPANY

ALBIN H. ABRAHAMSON	LEO F. DESJARDINS	LOUIS IACAMPO	BYRON G. MILLER
ROBERT A. BARTELS	GEORGE F. DONELAN	EDMUND L. JACQUES ★	WILLIAM F. MURPHY
DONALD BLACKBURN	WILLIAM T. DOWNES	JOSEPH V. JACQUES	JOSEPH S. NEUNER
KENNETH BOOTH	JULIUS J. EIBEL	EMIL O. KRAEMER	DONALD NEVILLE
HERVE W. BROUILLARD	PATRICK A. FALVEY	JOSEPH A. LaMONTAGUE	LOUIS PETRONELLI
EDWARD W. BURNS	GEORGE H. GAUMOND, JR.	EDWARD LAVERY	ALBERT ROCCO
JOSEPH F. GARNEY	ANTHONY GEREMIA	HOWARD LOGEE	LAWRENCE E. SEAVOR
IRVING L. CHAMBERLAIN	WALTER J. GILBERT, Jr.	JERRY V. LORENZO	ADOLPH UHRIG, Jr.
ARTHUR CHAPPRON	EDWARD T. GILL	FREDERICK J. MACK	LOUIS N. ULLMAN
PAUL CHURGH	BENJAMIN E. GRECO	JULIUS E. MACKOWITZ	ANTHONY VICARIO
ANTONIO CIAMPANELLI	EDWARD K. HARDING	ANTHONY B. MARLOWE	WILLIAM F. WALLACE
THOMAS A. CONNOR	HERBERT W. HAWKSLEY	JOHN J. McCARRON	GEORGE WHITE
THOMAS CULLEN	JAMES F. HENCHEY	GEORGE A. MENNINO	OSCAR S. WISCHNOWSKY
GEORGE J. CUNHA	WARREN HINTERLAND	CHARLES E. MILLER	GIUSEPPE L. ZOGLIO
GEORGE DAVIDSON	JOSEPH F. HORNER	HENRY F. MILLER	

"That Liberty Shall Not Perish from the Earth"

This World War II sign hung inside the brewery and displayed the names of workers who served during World War II. (Courtesy of Ed and Greg Theberge collection; photograph by Emmet E. Turley.)

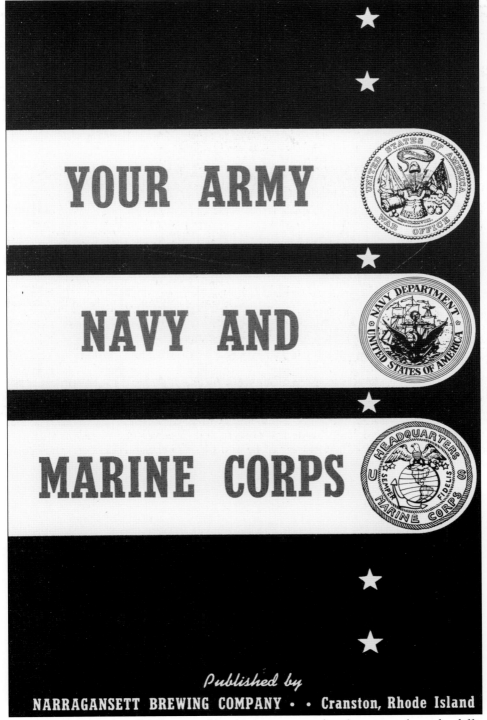

YOUR ARMY

NAVY AND

MARINE CORPS

Published by
NARRAGANSETT BREWING COMPANY · · Cranston, Rhode Island

This is a World War II handbook, printed by the company, with information about the different branches of the U.S. armed forces. (Courtesy of Ed and Greg Theberge collection.)

This photograph shows the brew house as it matched all the other brick buildings at the brewery site. (Courtesy of Bowerman Brothers.)

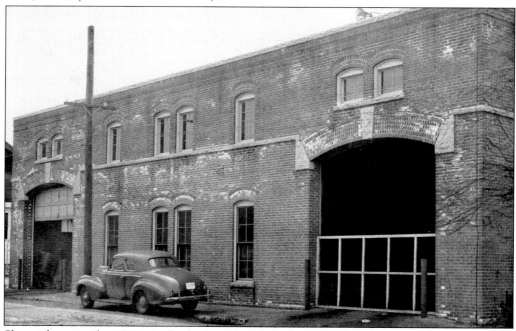

Shown here in the 1940s is the boiler house, which supplied power to all the buildings. It could use oil, gas, or coal, and employees said it was a very hot place to work, especially in the summertime. (Courtesy of Bowerman Brothers.)

Many neighborhoods displayed Narragansett Brewing Company signs for bars and package stores after the war years. This sign still remains in 2006, in Newport, but the store is all boarded up. (Photograph by Hazel B. Turley.)

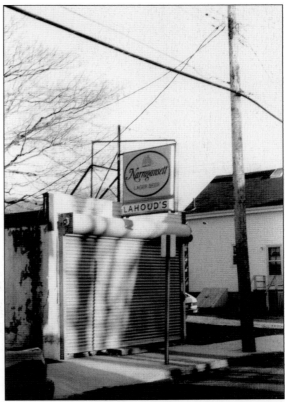

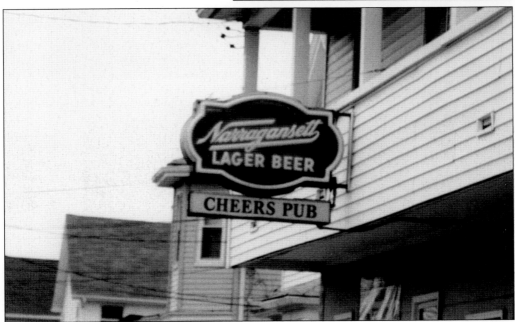

This sign was one of a few remaining in 1998. It was displayed in front of a small neighborhood bar, Cheers Pub, in Cranston, not far from the brewery site. (Photograph by Hazel B. Turley.)

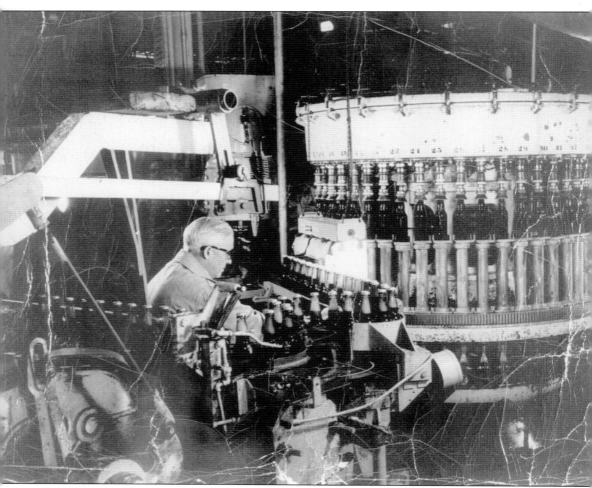

Seated here is John Martinelli, inspecting bottles for foreign objects. He did this very important and tedious job for many years, finding many curious items such as coins, hairpins, and so on. (Courtesy of Betty M. Thomaselli.)

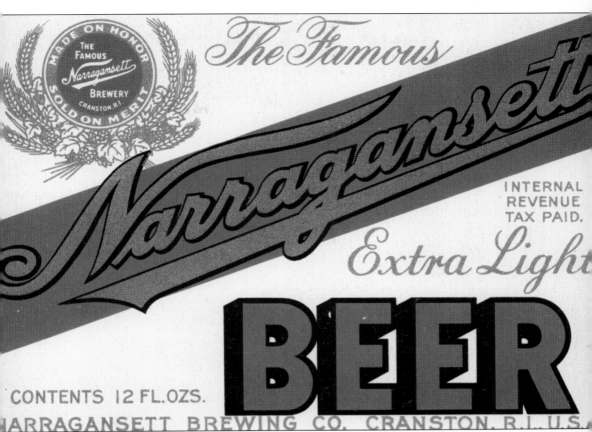

The extra light beer was introduced in a 12-ounce bottle in post-Prohibition days. Note that the label states "Internal Revenue Tax Paid." (Courtesy of Ed and Greg Theberge collection.)

The Narragansett beer bottle with an arrow through it was part of a promotional program. A label on the back of the bottle asked folks to send in ideas as to how it was done. (Courtesy of Alice Russell; photograph by Emmet E. Turley.)

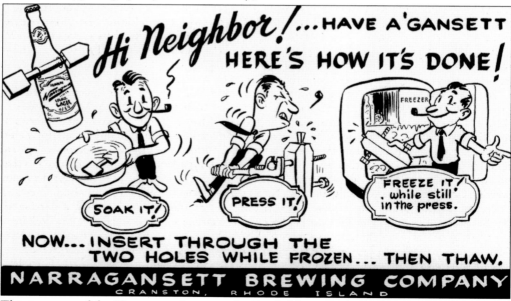

This is a copy of the "Answer to Arrow in the Bottle." It states the trick was to soak the wood, press it, freeze it, and then "insert through the two holes while frozen." (Courtesy of Ed and Greg Theberge collection.)

Five

ACQUISITIONS AND GROWTH
1950–1960

Many other changes were to occur in the 1950s and 1960s with the creation of an elaborate and devoted sales department. The mission was to make Narragansett beer the choice of all New England. The Haffenreffers made a decision to upgrade their brewing capabilities and extend their selling capacity within the Northeast. Many of their former employees returned from the war; however, the management realized it needed a brewmaster with expert technical knowledge to lead the brewery forward in this direction. They found these skills in John Strauss, a native of Germany who came to the United States in 1929. He worked at breweries in New York and Pennsylvania, and during World War II, in New York, he was in charge of the malt syrup production for the U.S. Army food supply source. During this time he attended Muhlenberg College, Newark College of Engineering, Columbia University, and the U.S. Brewing Academy. In 1947, he started working for the Narragansett Brewing Company in Cranston and put his superior knowledge and skills into the new technology and equipment to produce a superior beer.

Cafes, lounges, and neighborhood bars were everywhere with special signs that advertised the name of the places along with the logo of the Narragansett Brewing Company: "Hi—Neighbor, Have a 'Gansett!" This was the official greeting to all. When a patron entered and requested a beer, he almost always got a mug of draft Narragansett beer. If he wanted to order something else to drink, he had to whisper his request. During this time Narragansett Brewing Company began a period of plant growth and increased production of various types and names of beer, as well as the famous Narragansett Lager. Beginning in 1954, several breweries were acquired by Narragansett Brewing Company, and eventually in 1965, Narragansett itself was acquired by Falstaff Brewing Company. In 1954, Narragansett purchased Croft Brewing Company, and in 1957, it purchased Hanley Brewing Company in Providence. Some of the equipment was saved, but the buildings were demolished to make way for Interstate 95. In 1957, Narragansett acquired the right to produce Boh Beer from Enterprise Brewing Company of Fall River, Massachusetts. In 1965, the company purchased Krueger Brewing Company in New Jersey, and in that same year, Falstaff bought Narragansett Brewing Company in Cranston. In 1971, Narragansett (read Falstaff) purchased Haffenreffer Brewing Company in Massachusetts and also acquired the Ballantine Brewing Company in New Jersey. All of the breweries purchased by Narragansett were shut down, and eventually 19 different types of beer, including those acquired, were produced in the facility in Cranston. The Croft, Haffenreffer, and Ballantine plants were used as distribution plants.

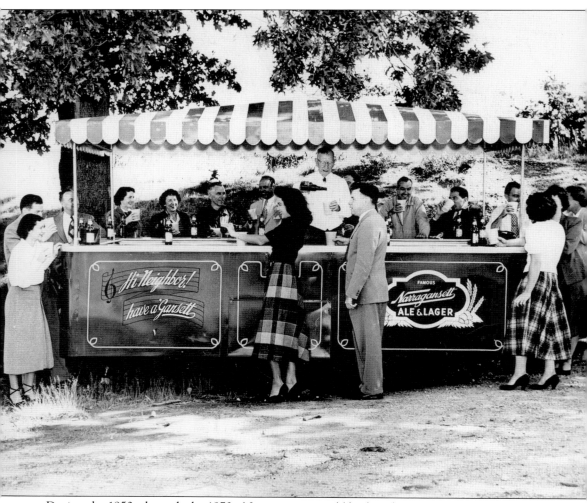

During the 1950s through the 1970s, Narragansett could be found at many public venues such as fairs and outings. Stands such as this one from around 1950 were transportable from site to site. (Courtesy of Ed and Greg Theberge collection.)

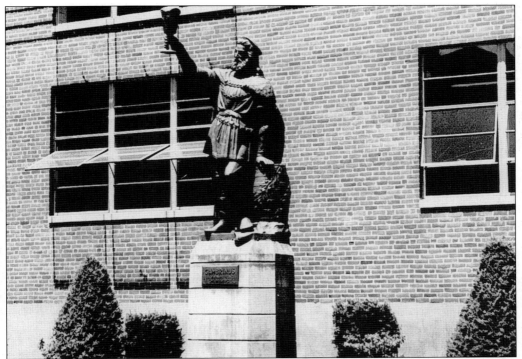

This statue of Gambrinius, the legendary god of beer, is shown in earlier days. With his right arm raised, he proclaimed a toast to all who worked in or visited the brewery. (Courtesy of Anthony Strakaluse.)

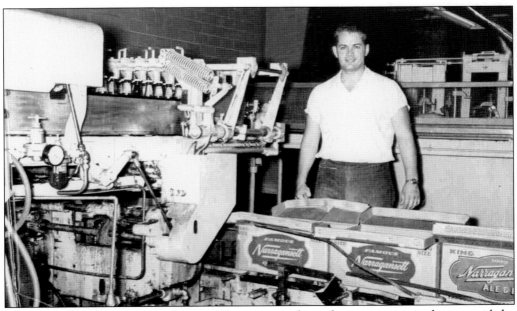

Irving Angell, a Narragansett Brewing Company employee for many years, is shown amid the machines, conveyor, and cases of beer in the bottling shop. (Courtesy of Karen Angell.)

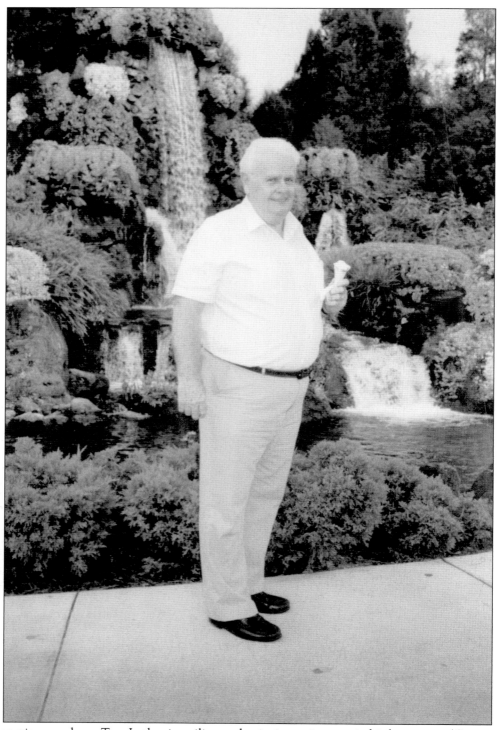

Longtime employee Tom Luther is smiling and enjoying retirement in his later years. (Courtesy of Frances Luther.)

This lists the names of the union members. Most employees belonged to the International Union of Brewery Workers, affiliated with the American Federation of Labor and Congress of Industrial Organizations (AFL-CIO). (Courtesy of Frances Luther.)

1.Harding	56.Doherty T.J.	111.Mulvey T.	166.Kee..r
2.Annicelli	57.Conca T.	112.McDonough J.	167.Curtis
3.Iecampo	58.Cassidy	113.Wilmot B.	168.Shaw
4.Ciampanelli A.	59.Lynch	114.Bergeron, I.	169.Paolantonio
5.D'Errico	60.Perkinson	115.O'Rourke	170.Healey E.
6.Sullo	61.Pezza	116.Campbell	171.Bessette
7.Sibilia	62.Robinson	117.Hutchings	172.DeMarco
8.DeMelo	63.Smith H.	118.Henna	173.Meagher
9.Strakaluse	64.Kelly T.	119.(Magnotta A.)	174.LaFontaine
10.Costello	65.Northup	120.Fantasia	175.Heaney R.
11.Chaffee	66.Bode	121.Flynn V.F.	176.Wilmot R.
12.Vigorito	67.Wilmot E.	122.McGovern I.	177.Annis
13.Berard	68.Gooden	123.Morenzi	178.DeSantis
14.Izzo	69.Meyer	124.Riccio	179.Morra
15.Corley	70.Nelson	125.Yagnesak J.	180.Tantimonico G.
16.Reichenberg	71.Bowen W.	126.Tinkham	181.Schmidt
17.Fournier	72.Hunter	127.Greco	182.Gagnon
18.Dempsey	73.Gevigan	128.Hooker	183.Weeden
19.Proulx	74.Conca F.	129.Studley	184.Tomasetti
20.Love	75.Bacon	130.Bourguignon	185.Cahalan
21.Mulcahey	76.Gormley	131.Brennan	186.McDonough E.
22.Casey	77.Gregoire	132.Battista	187.Smith F. C.
23.Davis	78.Pinney	133.McDermott L.	188.Balgano
24.Infussi	79.(Carrier)	134.Maloney	189.Carpenter
25.Stone	80.Suitor	135.Zanghi	190.Angeli
26.DeMeo V.	81.Octeau	136.Meyer	191.Croker
27.Kilkenny E.	82.Ruggieri	137.Crocker W.	192.Forsier
28.Byron	83.Chorney	138.Marquette	193.Moran
29.McCormac	84.Martino	139.Langan	194.Martin
30.Peloso Roy	85.Odsen	140.Williams	195.Price
31.Smith H. E.	86.Biacchi	141.Patrick J.S.	196.Hittle
32.Smith G.	87.Boghigian	142.Raymond	197.Gomes
33.Harlin	88.Doorbar	143.Gemma	198.Freeman
34.Hall	89.Bedard	144.Thompson	199.Whittaker
35.Wolf	90.Gaudet	145.Walch	200.Curran
36.Galligan	91.Larocque	146.Gildea T.	201.Manning
37.Keegan J.	92.Brown	147.Cusano	202.Sacioccia
38.Hallane	93.Capobianco A.	148.Killion	203.Uva
39.Buckley W.	94.Lehmann	149.Marcolivio	204.Higham
40.Petronelli	95.Barish	150.DeMeo A.	205.Lenney
41.Cushman	96.Ciampanelli V.	151.Schwarzenberg	206.Nawrocki H.
42.Gallo	97.Lancellotti	152.Yagnesak E.	207.Fellela
43.(Fagan)	98.Sullivan M.	153.Luther	208.Osterman
44.McNab	99.Macauley	154.Pagliarini	
45.Pilosa	100.Major	155.Lee	
46.Pilkington	101.Healey R.	156.Bracken	
47.Lemire	102.Tantimonico G.	157.Murphy	
48.Francis	103.(Devine)	158.Mastera	
49.Burgess	104.McGowan	159.Vincenzo	
50.Carlson	105.Magnotta F.	160.Bianco	
51.Heaney C.	106.Gildea W.	161.Coccio	
52.Osterman	107.Peloso Bob	162.Peloso F.	
53.Angell	108.Doherty F.	163.Sepe	
54.Johnson H.	109.DelPrete	164.D'Aguanno	
55.Maynard	110.Cyr	165.Duffy	

Arthur DeMeo
Secretary

The sign on the warehouse/bottle shop building was a welcoming sight to all who came to work in or visit the brewery. (Courtesy of Bowerman Brothers.)

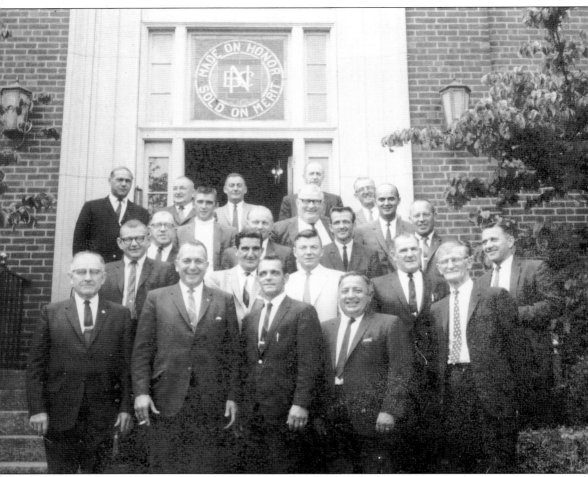

This mid-to-late-1950s photograph features the Narragansett management team in front of the brewery's administration building. Note the stained-glass window from the 1930s above the front door. This is one of the last remaining artifacts still in existence from the brewery during this time period. (Courtesy of Ed and Greg Theberge collection.)

This is a copy of the agreement between Narragansett Brewing Company and the brewery workers' union. Union dues were deducted from employees' weekly wages. (Courtesy of Harold Nelson; photograph by Emmet E. Turley.)

AGREEMENT

BETWEEN

Narragansett Brewing Co.

AND

International Union of United Brewery, Flour, Cereal, Soft Drinks and Distillery Workers of America, A. F. L. - C. I. O.

LOCAL UNION NO. 114

CONSTITUTION and BY-LAWS

OF

BREWERY WORKERS

Local Union No. 114

CRANSTON, RHODE ISLAND

AFFILIATED WITH

INTERNATIONAL UNION OF UNITED BREWERY, FLOUR, CEREAL, SOFT DRINK and DISTILLERY WORKERS OF AMERICA, AFL–CIO

Pictured here is another union book, with constitution and bylaws. (Courtesy of Harold Nelson; photograph by Emmet E. Turley.)

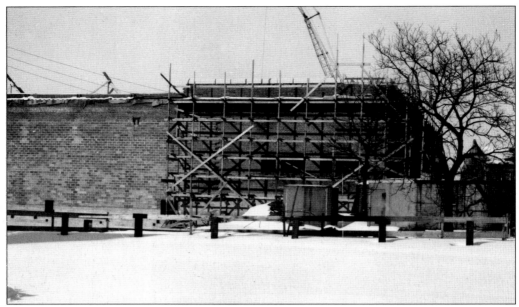

This is a photograph of the Narragansett Brewing Company construction site, part of the 1951 growth plan. The snow was not part of the plan. (Courtesy of Anthony Strakaluse.)

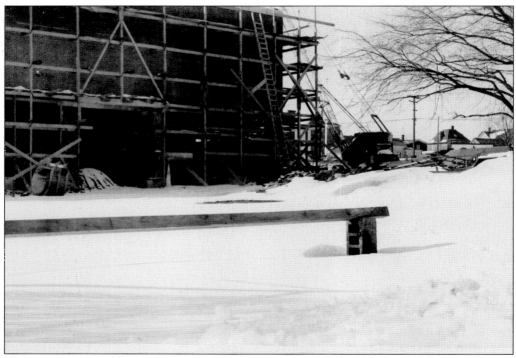

The construction site is shown here abandoned during a winter snowfall. (Courtesy of Anthony Strakaluse.)

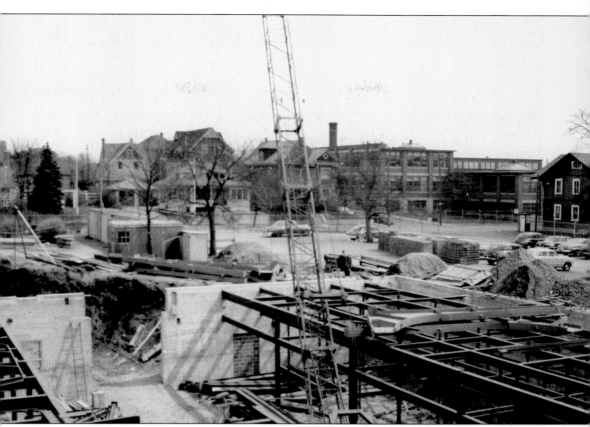

By 1952, spring construction proceeded very well. (Courtesy of Anthony Strakaluse.)

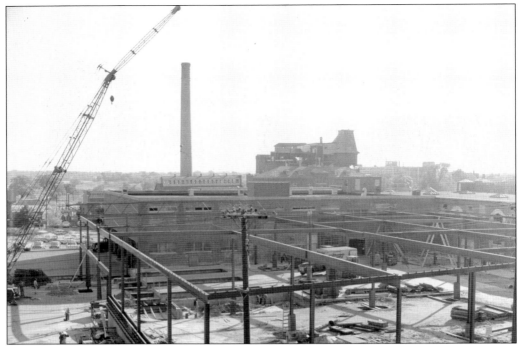

Very strong internal steel supports were installed in the warehouse and bottle shop building during construction in the 1950s. It was closed in 1983, and it was the first building to be razed in 1998. (Courtesy of Anthony Strakaluse.)

This distribution truck was parked at the site of the new warehouse building. Trucks were privately owned and hired to deliver beer throughout the region. The elaborate sign on the side was another piece of promotional advertising. (Courtesy of Anthony Strakaluse.)

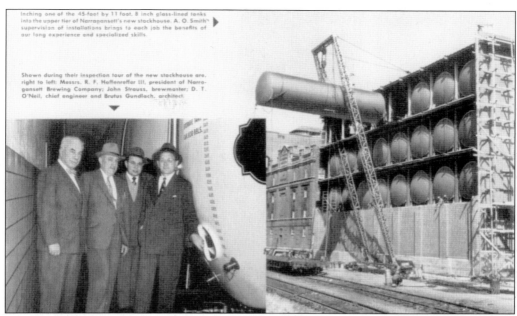

Inching one of the 45-foot by 11 foot, 8 inch glass-lined tanks into the upper tier of Narragansett's new stockhouse, A. O. Smith supervision of installations brings to each job the benefits of our long experience and specialized skills.

Shown during their inspection tour of the new stockhouse are, right to left: Messrs. R. F. Haffenreffer III, president of Narragansett Brewing Company; John Strauss, brewmaster; D. T. O'Neil, chief engineer and Brutus Gundlach, architect.

The management had to review the newly installed glass-lined tanks in the stack house. From left to right are Rudolph F. Haffenreffer III, president; John Strauss, brewmaster; Dan O'Neil, chief engineer; and Brutus Gundlach, architect. (Courtesy of Edmund Strauss.)

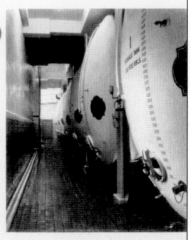
This was the newsletter account of the January 1954 installation of three floors of glass-lined tanks in the stack house. (Courtesy of Edmund Strauss.)

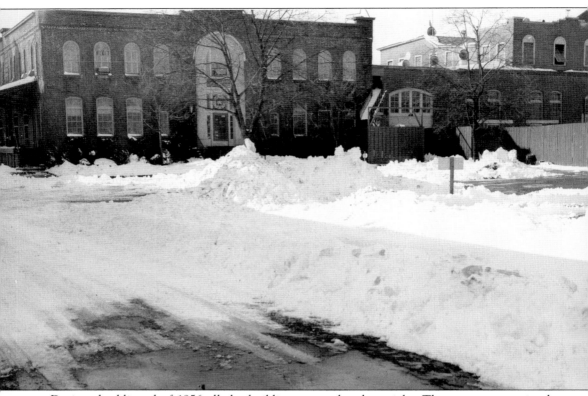

During the blizzard of 1956 all the buildings were closed up tight. There are no cars in the parking lot, despite the efforts of the snowplow. (Courtesy of Anthony Strakaluse.)

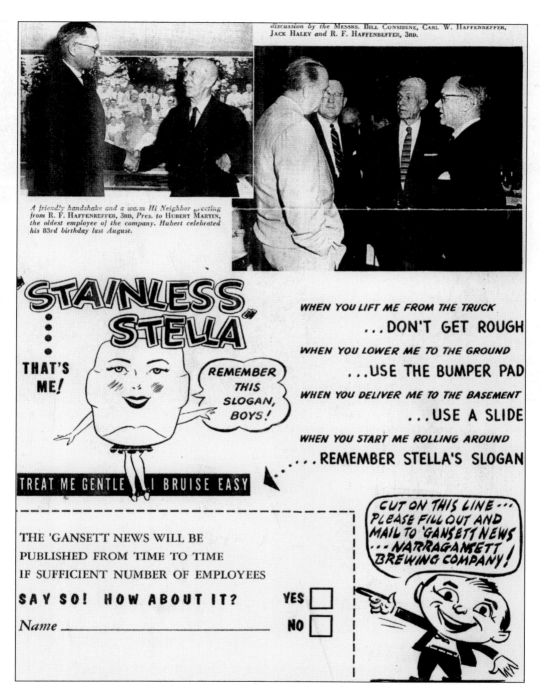

This is a page from the Narragansett newsletter with a photograph of the management group in the 1950s in the upper right. From left to right are William Considine Sr., sales; Carl W. Haffenreffer, owner; Jack Haley, advertising manager; and Rudolph F. Haffenreffer III, owner. The lower cartoon refers to the proper way of unloading kegs from the trucks. (Courtesy of Anthony Strakaluse.)

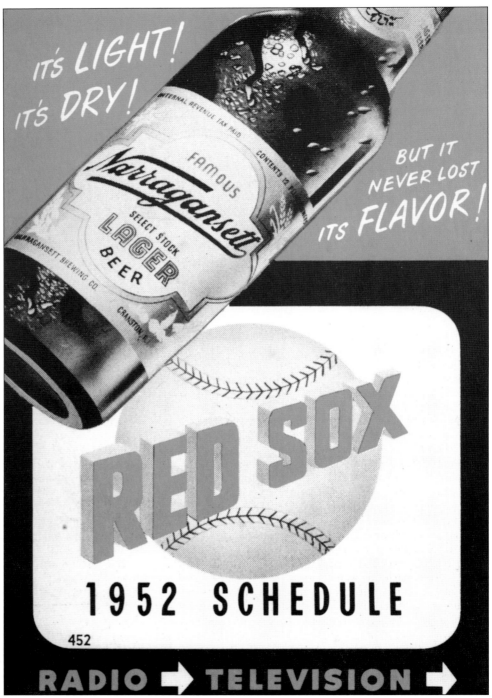

This is a copy of a 1952 Red Sox schedule sponsored by Narragansett Brewing Company. In it were the dates and times the Boston Red Sox were scheduled to play and to be broadcast on radio and television. These schedules were published on an annual basis and used for promotional purposes. (Courtesy of Ed and Greg Theberge collection.)

Six

NUMBER ONE IN NEW ENGLAND
1960–1969

David Haffenreffer recalled the years in the 1960s when Narragansett beer was the number one choice of beer in all New England. "I began working for the Narragansett Brewing Company in the fall of 1961, the year I graduated from college. My first assignment was to work with an advertising agency in New York City, with a budget in excess of a million dollars. There, I met the advertising managers of the brewery." After a year in New York, Haffenreffer returned to Rhode Island and worked in Cranston at the office with Jack Haley, Jack Reynolds, Harold Notte, Avis Stohl from Boston, and H. L. Morrissey, who was, most likely, from Providence. "We made up the team that was responsible for creating the advertising, placing it, and being sure that the distributors were adequately supplied with all of our promotional material. You name it, we did it!" It was an interesting time as the flip-top can had just been created, and back then it was a bonanza to have. Narragansett Brewing Company was one of the first to receive them from Reynolds Aluminum. It took that as a tremendous marketing advantage and made all sorts of displays and signs, with at least 12 to 18 different labels at that time. But the main beer, of course, was Narragansett beer, which was the largest selling beer in New England. "We achieved that standing by selling 1.2 or 1.3 million barrels, and that was very close to the capacity of the brewery. It was a great accomplishment to do that! Our television advertisements used the voices of Mike Nichols and Elaine May against some animated cartoons, and they were incredibly popular." These cartoons were humorous, topical, and had a smart kind of humor. They got people's attention not only on the air waves or in bars but also in package stores, where they were used as merchandising material. These advertisements were used in connection with the advertising for the Red Sox baseball team. "We had been sponsors of the team for 20 years, so as their longest running sponsor, it gave us a tremendous advantage as some extraordinary years of baseball were played since the end of World War II up to the 1960s. It was always a challenge to come up with a brand-new look and a brand-new campaign for us to keep our beer, Narragansett, as the leader, 'Number One!'"

This was the view inside of the new warehouse/bottle shop building with the glowing Narragansett Brewing Company sign in the 1960s. (Courtesy of Bowerman Brothers.)

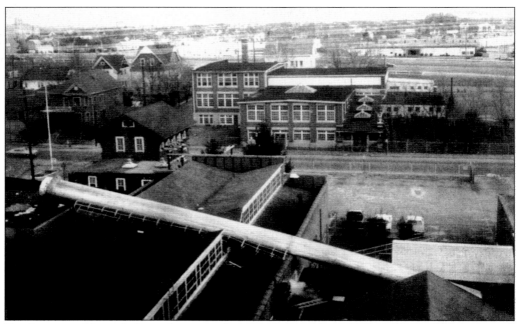

Employees could not believe the storm that struck was so severe that the wind blew this tall chimney down on the premises. (Courtesy of Anthony Aurrechia.)

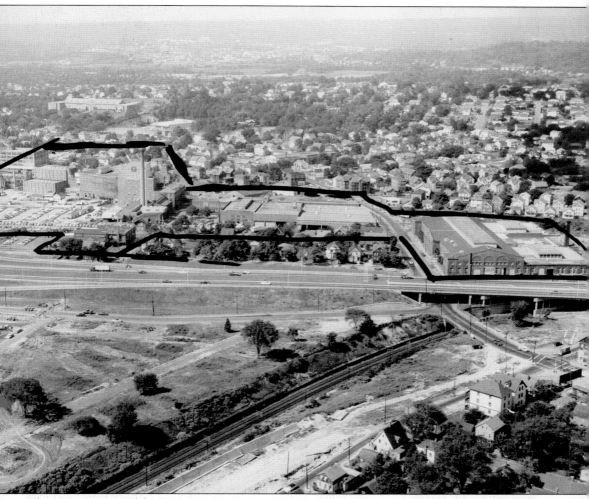

This is a rare view of the Narragansett Brewing Company property from the air in 1962. The site extended over 40 acres, with the brew house on the left and the old trolley barn on the right as distinctive landmarks. (Courtesy of Bowerman Brothers.)

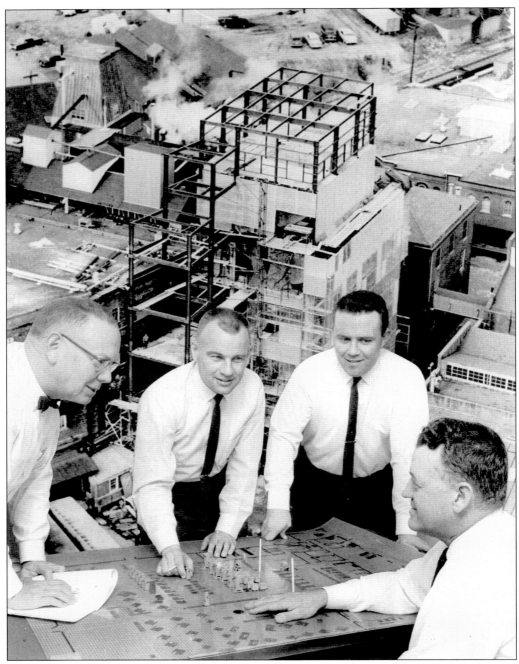

The Bowerman Brothers are shown at work, with the new brew house construction in the rear. They were a team responsible for upgrading many of the brewery buildings during this era. From left to right are Harry Livezey, J. R. Wahlberg, John Livezey, and F. Bowerman. (Courtesy of Bowerman Brothers.)

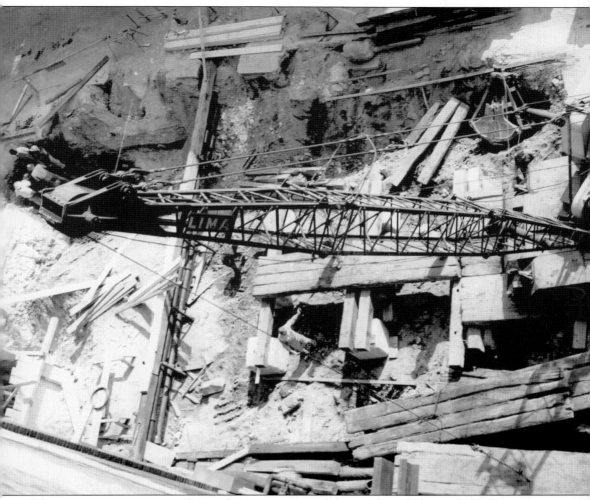

This is an excavation scene during the construction of the new brew house in 1962. (Courtesy of Bowerman Brothers.)

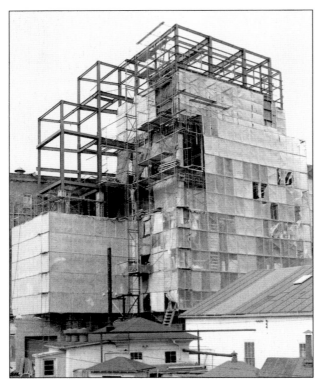

This is a view of the new brew house addition in 1962. In order to make space for expanding production, the plans called for making this building much taller than the previous one. (Courtesy of Bowerman Brothers.)

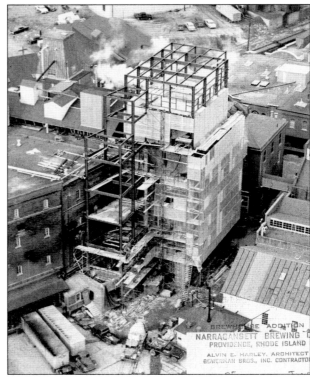

This is another special view of the brew house from the top as viewed by the builders. (Courtesy of Bowerman Brothers.)

This was the top part of a welcoming brochure given out on the brewery tour to explain the brewing process and show folks the various sections on the tour. (Courtesy of Edmund Strauss.)

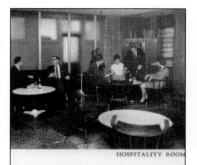

HOSPITALITY ROOM

Welcome

...to New England's largest brewery, The Narragansett Brewing Company. Narragansett is a wholly-owned subsidiary of Falstaff Brewing Corporation, St. Louis, Mo., fourth largest brewer in the United States.

Here you will see the cleanliness and scientific exactness that prevails in every step of Narragansett's brewing operation ... assuring complete quality control at all times.

Hi neighbor

NARRAGANSETT
BREWING COMPANY
CRANSTON, RHODE ISLAND

This was the bottom part of the brochure, featuring the statue of Gambrinus, given out to visitors by the affable tour guide John English. (Courtesy of Edmund Strauss.)

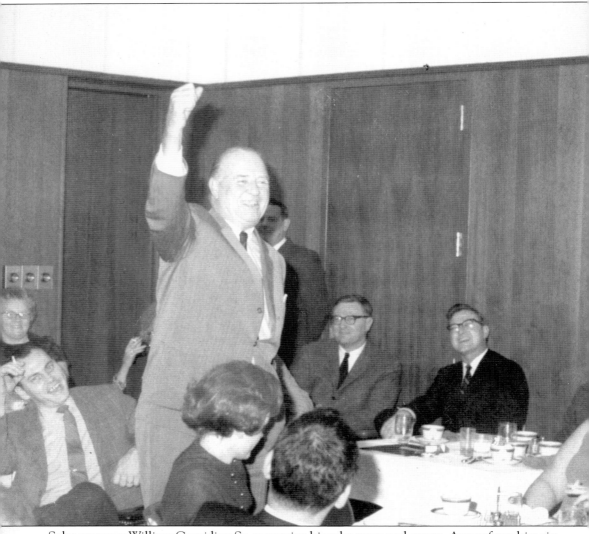

Sales manager William Considine Sr. entertains his sales team and guests. Across from him sits J. Joseph Garrahy, who worked as a Narragansett Brewing Company salesman years before he became Rhode Island governor in the 1970s. (Courtesy of William Devereaux.)

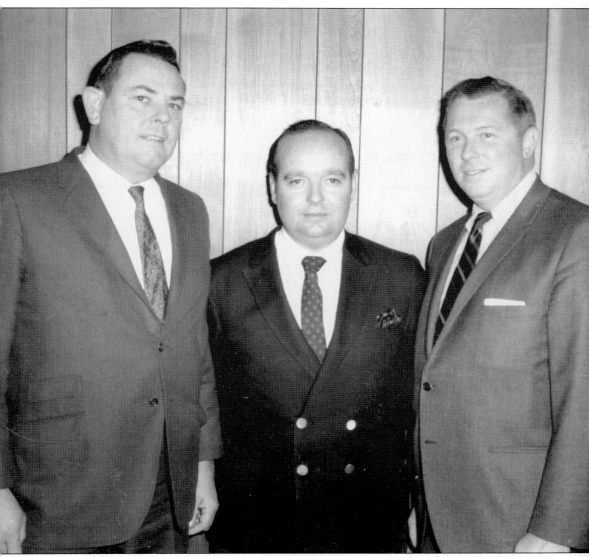

Members of the sales team in the 1960s included these three men who with their creativity, along with others in sales and advertising, helped Narragansett beer to become "No. 1 in New England." From left to right are William Devereaux, Robert Webb, and Jim Nolan, who also handled public relations. (Courtesy of William Devereaux.)

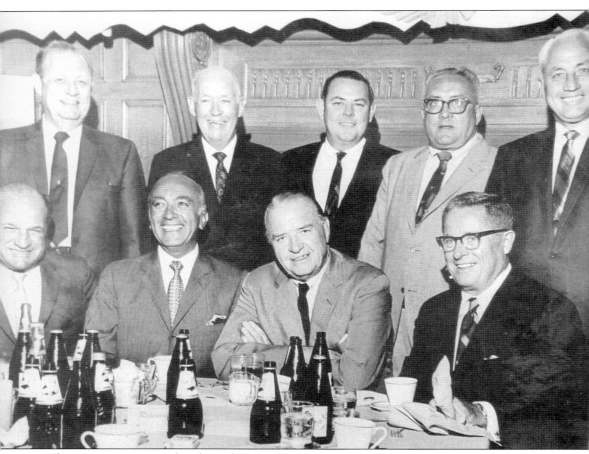

This picture was created and sent by sales director William Considine Sr. as a thank-you, along with words of praise, to all the members of the sales team. (Courtesy of William Devereaux.)

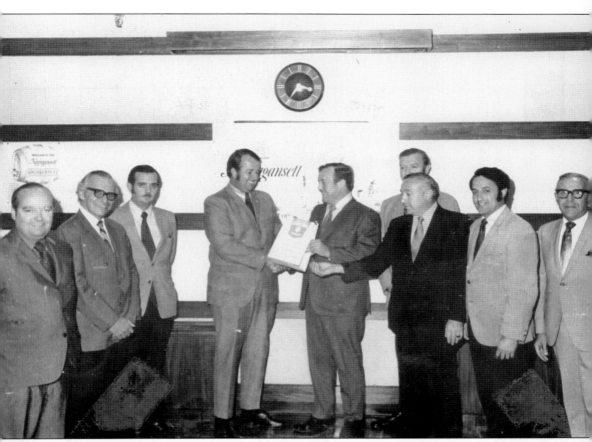

Members of the sales team receive awards during an event in the 1960s. (Courtesy of William Devereaux.)

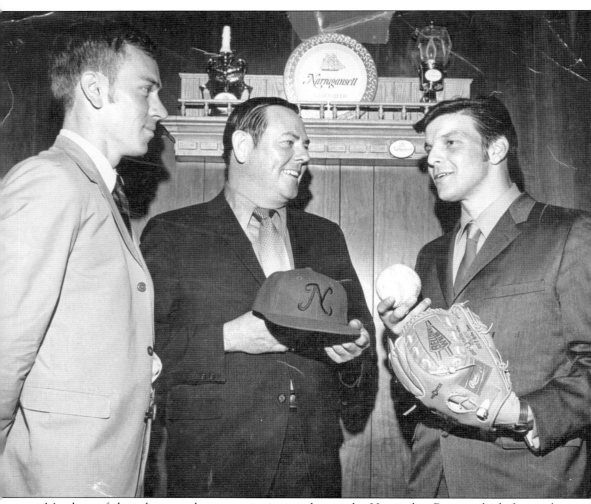

Members of the sales team honor a winning pitcher in the Hospitality Room, which featured 1890 decor and was used to do the tours and to welcome special guests to enjoy Narragansett beer. (Courtesy of William Devereaux.)

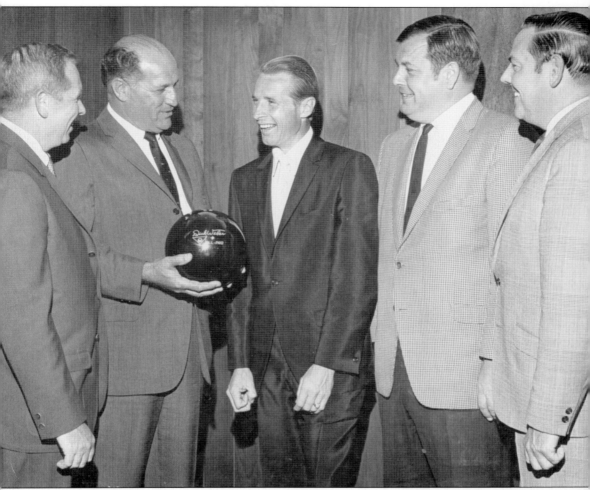

Here members of the sales team are shown welcoming champion bowler Dick Weber. From left to right are Jim Nolan, Al Faenza, Dick Weber, Barry Sullivan, and William Devereaux. (Courtesy of William Devereaux.)

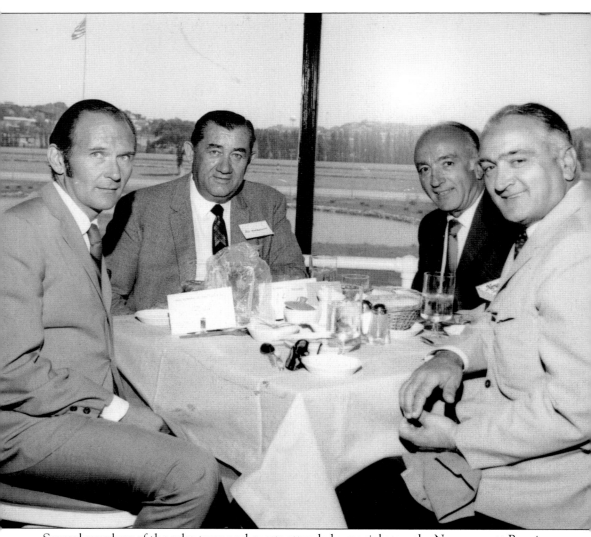

Several members of the sales team and guests attended a special race, the Narragansett Brewing Company Purse, at Suffolk Downs racetrack. (Courtesy of William Devereaux.)

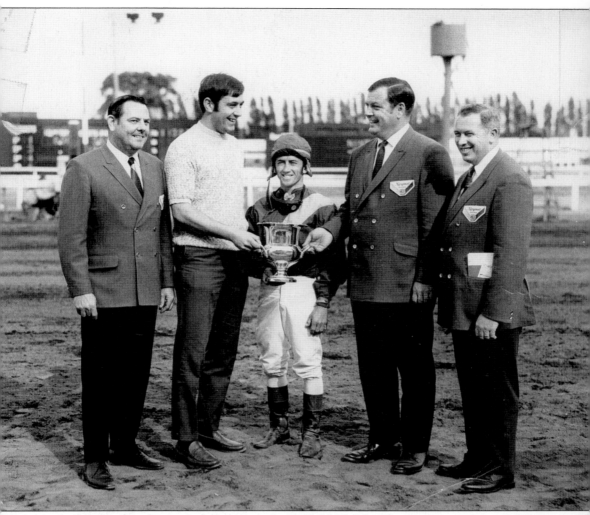

At Suffolk Downs, the winning horse was Look Don't Touch. The winning jockey was Leroy Moyers, the trainer was J. J. Lenzini, and the purse was $10,000. From left to right, William Devereaux, Barry Sullivan, and Jim Nolan present the trophy in this image. (Courtesy of William Devereaux.)

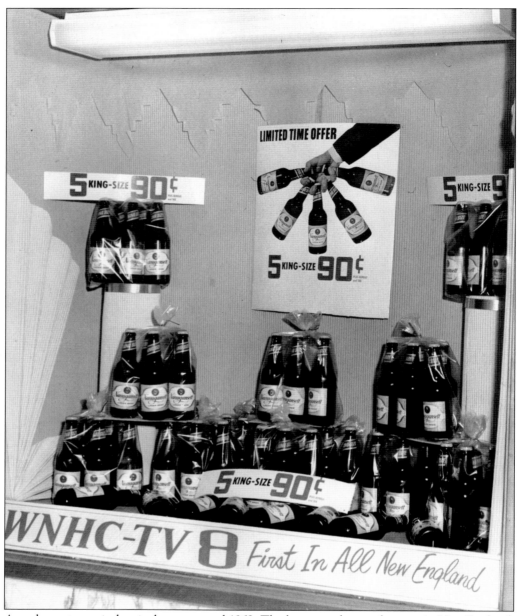

A package store window is shown around 1962. The beer was the number one in New England, and Narragansett was an official sponsor of the Boston Red Sox, which could be seen on Channel WNHC. (Courtesy of Ed and Greg Theberge collection.)

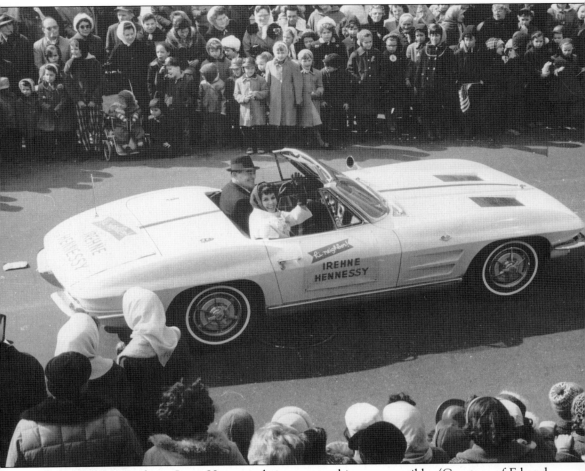

This parade scene shows Irene Hennessy being escorted in a convertible. (Courtesy of Ed and Greg Theberge collection.)

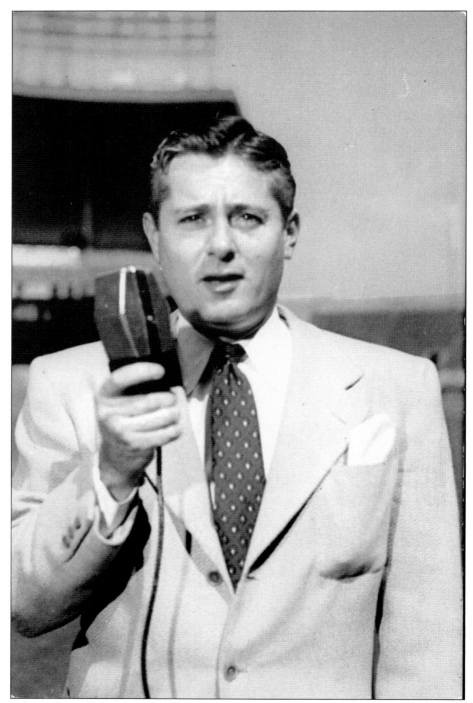

Throughout the 1950s and early 1960s, Curt Gowdy was the voice of the Boston Red Sox, and Narragansett Lager beer was the official sponsor of the team's broadcasts. Those who tuned in heard his famous calls of "Hi—Neighbor, Have a 'Gansett," making the slogan synonymous with the famous ball team. (Courtesy of Ed and Greg Theberge collection.)

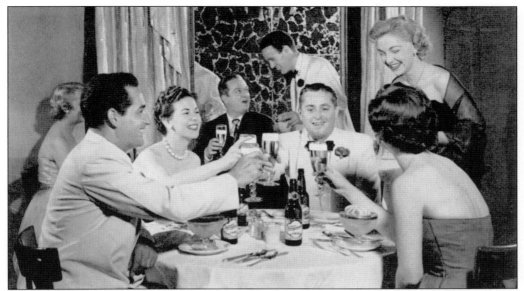

This photograph is from a series of postcards featuring Curt Gowdy, seen here with friends enjoying dinner with lots of 'Gansett. Gowdy was renowned for being a longtime announcer for the Boston Red Sox. (Courtesy of Ed and Greg Theberge collection.)

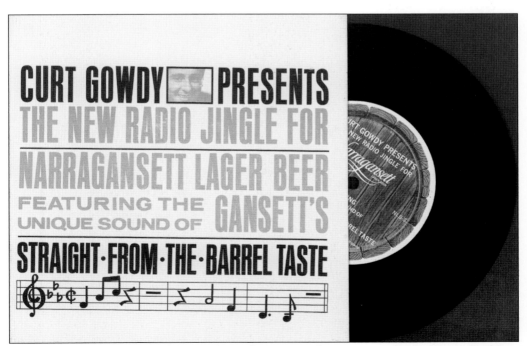

This favorite record, "Hi Neighbor Jingle" with Curt Gowdy, announcer for the Boston Red Sox, was played on radio and television. (Courtesy of Ed and Greg Theberge collection.)

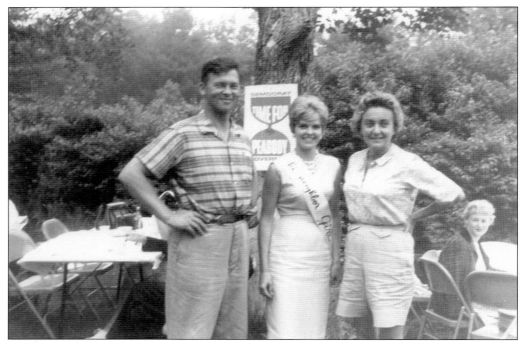

Here Vivian Brunelle (center) is sharing a happy moment with Massachusetts governor Endicott Peabody and his wife on the campaign trail in 1962. (Courtesy of Vivian Brunelle.)

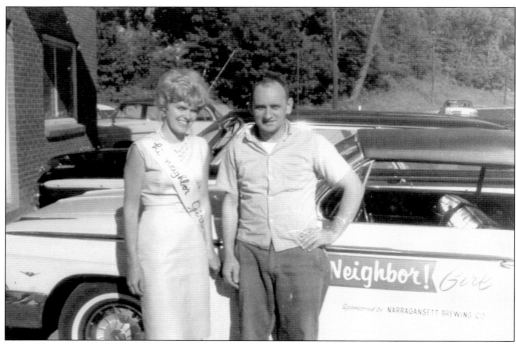

Brunelle is posing here with the yellow Chevrolet Impala convertible that she used for the year she was a Narragansett Brewing Company "Hi Neighbor Girl." (Courtesy of Vivian Brunelle.)

NET CONTENTS ONE PINT OR 16 FL OZ

Private Stock Malt Liquor is the ultimate in brewing art. Made from choice and expensive ingredients under a private formula and long aged in our cool brewery cellars.

SERVE WELL COOLED IN A TALL GLASS OR ON THE ROCKS

K

This was the Haffenreffer label for malt liquor. The Haffenreffer Brewery was closed; however, the malt liquor continued to be brewed by Falstaff after it purchased the Narragansett Brewing Company.

Hi-Neighbor!
Have a 'Gansett the "FRESH" one

The friendly "Hi Neighbor" bumper sticker was a novelty and was seen on cars and trucks all over New England. Jack Haley, advertising manager, was credited with coming up with this catchy phrase, which was based on his daily greeting to his neighbors as he collected his morning newspaper. Upon hearing him yell to them "Hi neighbor, want a 'Gansett?" the two old spinsters, sitting on their porch, would scream "No!" to him, go in, and slam the screen door. Haley would just laugh, but he decided to use it in his advertising, and it became an instant hit. (Courtesy of Ken Abrahamson; photograph by Emmet E. Turley.)

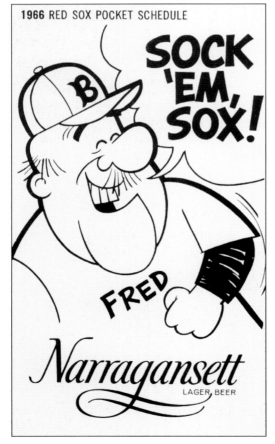

This 1966 Boston Red Sox schedule features Fred Gansett, a short-lived advertising character. (Courtesy of Ed and Greg Theberge collection.)

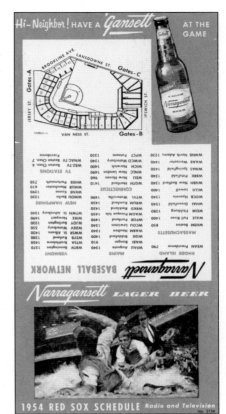

Featured on the right is a 1954 Red Sox schedule. Below, a 1956 schedule shows a pretty young lady enjoying a glass of Narragansett Lager. (Courtesy of Ed and Greg Theberge collection.)

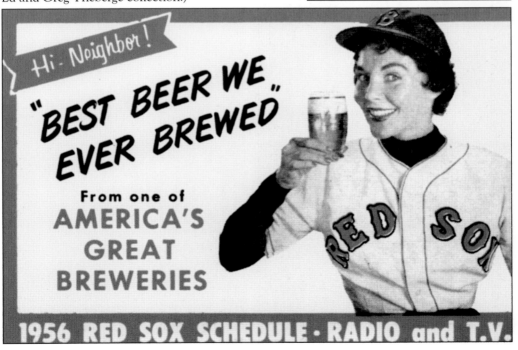

Examples of Excellence

WHEN IT COMES to beer, excellence is not measured by the barrel. It is measured drop by golden drop by the consumer. He wants a beer that not only satisfies his thirst and pleases his palate... he wants *consistent* drinkability from bottle to bottle wherever he may buy it.

Such quality is not left to chance at Falstaff. Our products are produced and packaged with pride... for we know that they are the best beers in the world.

Guardians of Quality

DEDICATED, CAPABLE, VIGILANT ...they all describe John Strauss, our master brewmaster. This German-born master brewer has gained the respect of the industry during his nearly four decades of brewing.

From the beginning of a brew, throughout the complete production and packaging cycle, Strauss and his staff perform 286 separate and distinct quality checks to assure the excellence of our beers.

The Skills of Our Master Brewers

BEER IS a very personal thing to the men who brew it. Their skills, which mean the difference between merely good beers and great ones, are acquired only through years of training and experience.

Normally, before an individual can achieve the title of master brewer he must have completed at least a decade of training. In our breweries, skilled master brewers oversee all phases of brewing, fermentation, aging, filtration, and finishing.

We Produce Our Own Custom Malted Barley

THROUGHOUT the growing season in America's great barley country, experts from our malt house inspect the crops. At harvest time, they custom purchase only the finest, premium six-row barley.

There's magic in our malt house, as millions of bushels of select grains are steeped, naturally germinated, rippletoasted, and then shipped in sealed, custom-built hopper cars to our breweries across the nation.

The *Falstaff Newsletter* was published in the 1960s, and this issue had items about the talented brewmaster John Strauss on the top side. (Courtesy of Edmund Strauss.)

Temperature

THERE IS A GREAT range of temperatures involved in the brewing and packaging of fine beers...they go from a frosty 29° all the way up the scale to 215° Fahrenheit. The exact temperature at any given point in the process can be very critical...so much so that temperatures are held to a tolerance of only one quarter of one degree in some instances. Obviously, such standards of excellence require meticulous, constant attention

Best by Taste Test

FALSTAFF BEER is significantly preferred for overall taste acceptability. This was proven in a series of 7,681 taste comparisons, with Falstaff versus other leading national and regional brands.

Adult male beer drinkers in widely scattered sections of the country participated...judging the beers on the basis of visual and aromatic grading, plus specific taste characteristics.

You can taste the difference pride makes.

BEER HAS BEEN WITH US for centuries. A 4,000-year-old Assyrian clay tablet found in the ruins of Nineveh mentions that beer was among the provisions taken aboard Noah's Ark.

Of all the drinking vessels created by man, the most beautiful are the beer steins crafted by the Germans and prized by today's collectors. The earliest were made of stoneware, hence the name, "Stein."

The standard measure of the brewing industry is the 31-gallon barrel. The wooden barrel of old weighed in at a hefty 400 pounds when full. Today's metal half-barrel is easier to handle, weighing 160 pounds filled.

There are 330 twelve-ounce servings, or 55 six-packs, or 13.7 cases of beer to the barrel.

Based on total U.S. population, annual per capita consumption of beer is 17.8 gallons or slightly more than one-half barrel. When figured against the adult population only, consumption per capita comes to 29.7 gallons or nearly a barrel a year.

For interested students of physics, it would take 407,272 barrels, or 134,400,000 twelve-ounce bottles or cans of beer to float the 45,000-ton battleship Missouri.
—Source: "Falstaff's Complete Beer Book"

Public Relations Dept., Falstaff Brewing Corp.,

The *Falstaff Newsletter* had interesting beer tidbits found on the bottom side. (Courtesy of Edmund Strauss.)

Seven

SPECIAL EVENTS
1965–1975

As stated earlier, Carl W. Haffenreffer drafted a "Friendly Neighbor Policy," which contained the company's rules for the treatment of customers and guests. He ended by saying "let us all become salesmen; salesmen for our product, and salesmen for our company. No other industry relies more upon good will, neighborliness, and friendship of the public than does the brewing business." Teams were active throughout all New England promoting this hospitality. They came up with all sorts of events and gifts to present to employees and their families, distributors, customers, and the public. Many times these gifts were given as mementos of special events. Most often they were planned to gather more friends and to gain customers to buy and enjoy their beer. Some events were planned for the seasons of the year, such as the bock beer festival in the spring and the Octoberfest held in the fall. Some events were for the employees and families, such as outings, Red Sox games, and Boston Pops musical concerts.

Many events were cosponsored with other groups to help raise money for charitable purposes. One such event was organized to be held in Point Judith as a fishing tournament. It was planned by a group of avid fishermen in nearby Galilee. They decided to approach Narragansett Brewing Company for help as a sponsor. William Mancini, chairman of the event, visited William Considine Sr., sales director, to request help with the project. Considine asked, "How much would it cost?" Mancini answered, "$20,000." Considine replied, "No way!" Mancini resumed the conversation, "How about $10,000?" Considine this time smiled and said "OK!" Then the board of directors and Jim Nolan worked together and came up with a name and a logo using the slogan "Hi Neighbor!" with the seal of the contest beneath it. The event was called the Hi Neighbor Point Judith Bass and Blue Fish Tournament. It was to be held on August 11–14, 1967. Besides Narragansett Brewing Company, other local businesses and friends donated money to buy trophies for the various categories of entrants. For three days, thousands of visitors came to Galilee to see the first-place winners as well as fish being caught from land and sea.

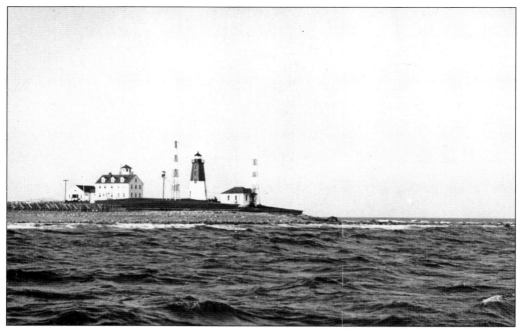

This is a photograph of the Point Judith Lighthouse in Point Judith, where several local fishermen organized a weekend event, a fishing contest. They called it the Hi Neighbor Point Judith Bass and Blue Fish Tournament. Narragansett Brewing Company was one of the main sponsors. (Courtesy of William Mancini.)

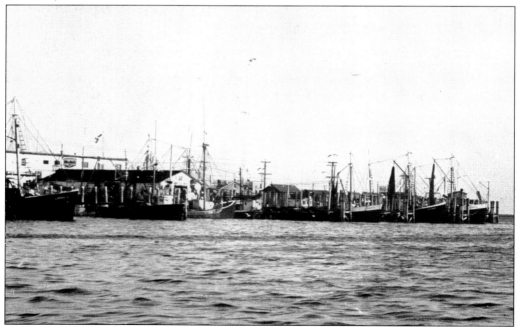

Many of the events took place at this neighboring port, called Galilee. It has a tranquil harbor and many fishermen. In three days, there were over 3,000 pounds of fish caught, and all was donated to charity. (Courtesy of William Mancini.)

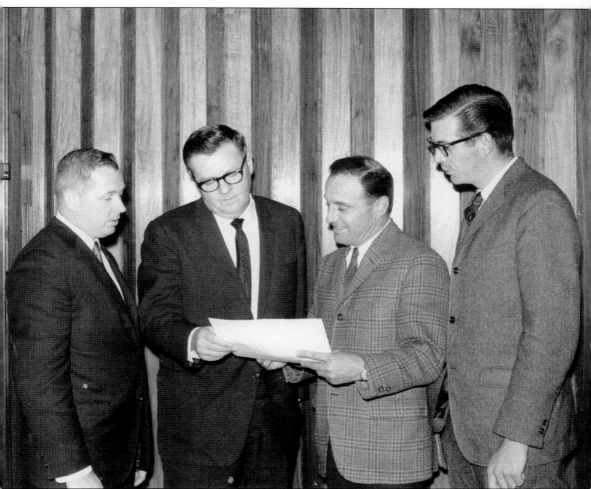

Two tournament directors and two Narragansett Brewing Company officials review the logo for the event, which featured the company greeting "Hi Neighbor" on top of a white shield shape and along the lower part read "Narragansett, R.I." From left to right are Jim Nolan, Narragansett Brewing Company public relations, and William Considine Sr., sales manager, along with William Mancini, tournament president, and Capt. Alan Anderson, tournament secretary, both Hi Neighbor Point Judith Bass and Blue Fish Tournament members. (Courtesy of William Mancini.)

An official sign proclaimed the Narragansett Brewing Company as sponsors of the tournament, and the application form read that "all profits go to the United Fund." From left to right are Cy Killian, United Fund; William Mancini, tournament president; and Clifford Gifford, United Fund. (Courtesy of William Mancini.)

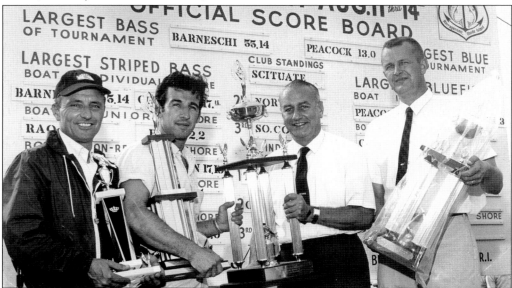

At the top of the official scoreboard sign are the official Hi Neighbor logos, and in the center is the welcoming slogan again. In the background is the listing of the various awards. Standing with trophies from left to right are William Mancini; Robert Barneschi; the lieutenant governor of Rhode Island; and Charles Boyle, director of the Department of Natural Resources of Rhode Island. Barneschi caught the largest bass, which weighed in at 55.14 pounds. (Courtesy of William Mancini.)

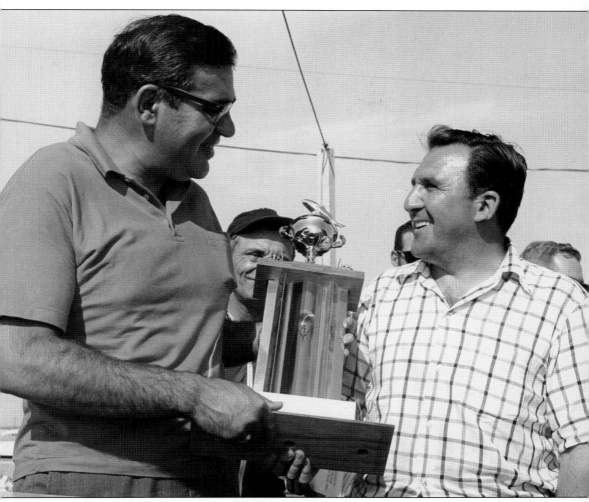

Herb DeSimone (left), former Rhode Island lieutenant governor, was happy to award the trophy to the captain of the boat that caught the most pounds of fish. (Courtesy of William Mancini.)

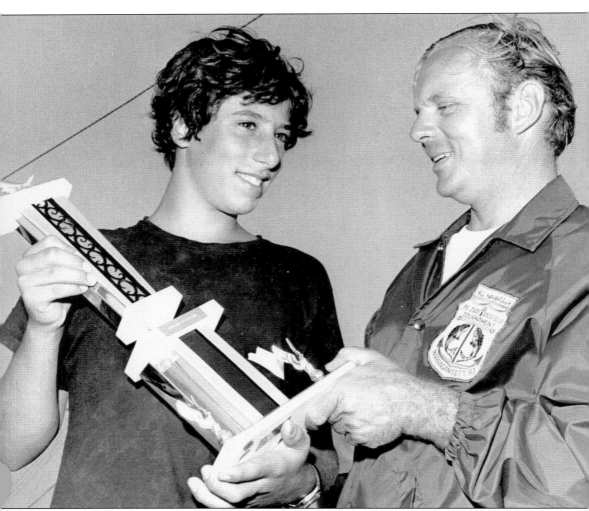

Al Lewis, as vice president of the tournament committee, presents the award for the largest bass caught in the youth division. Note how elaborate this trophy is, including the fish figure on the top. (Courtesy of William Mancini.)

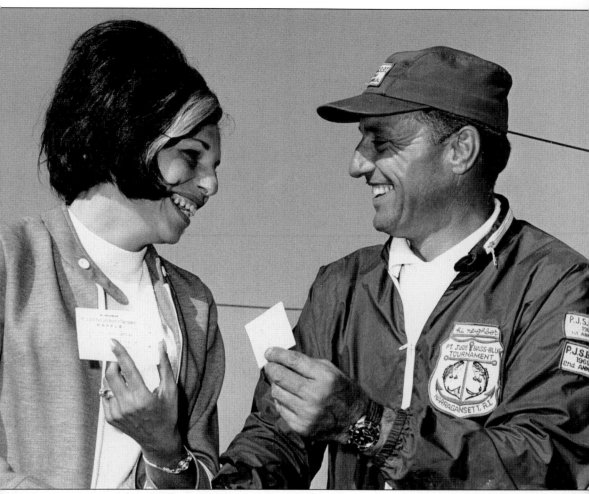

Tournament president William Mancini compares the ticket stub with the winner of the car. Mancini donated $5 toward the raffle and gave the five tickets to various folks. This woman had one of these tickets and drove away in the car donated by Ted Williams of the Boston Red Sox baseball team. (Courtesy of William Mancini.)

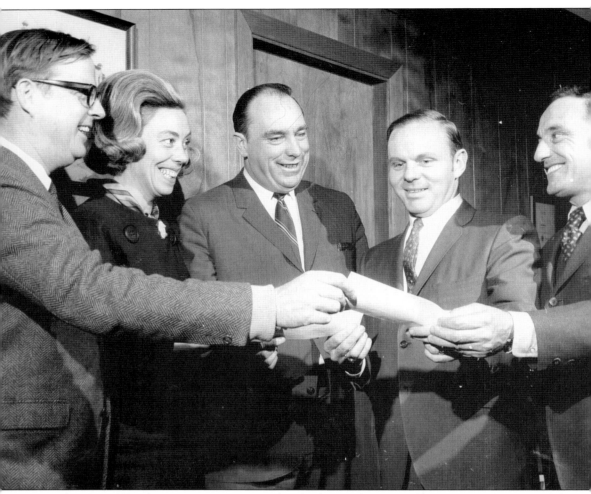

The United Fund representatives accept the check for a donation of $4,000. Seen here from left to right are Capt. Alan Anderson, Nancy DeWolf, two unidentified men, and William Mancini. (Courtesy of William Mancini.)

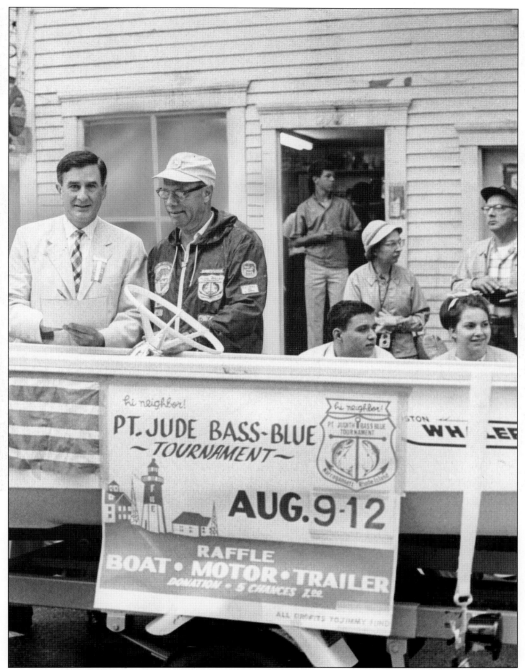

In the August 1968 event, Rhode Island governor John Chaffee worked with volunteers, helping with the raffling of a boat. This was preelection time for him that year. Although he sold a lot of raffle tickets, he lost the election in the fall. (Courtesy of William Mancini.)

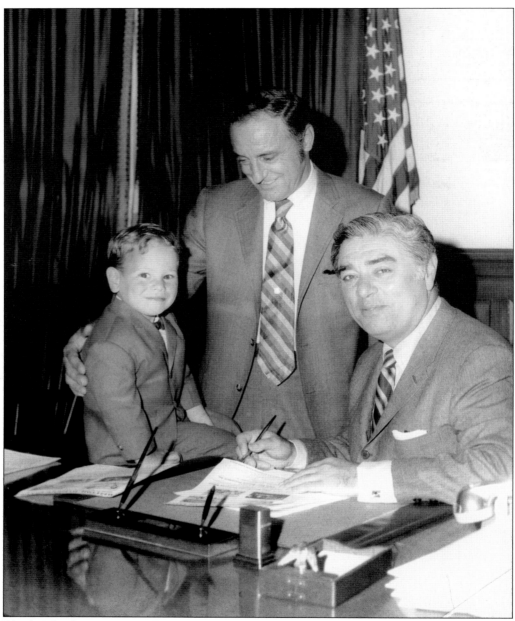

Rhode Island governor Frank Licht signs the proclamation for the event in August 1969. In his office for this occasion are William Mancini and a poster boy representing the charity selected for this event. (Courtesy of William Mancini.)

Arthur Fielder and the Boston Pops Orchestra perform for Narragansett Brewing Company family at a special event. From left to right, four unidentified guests assemble with Mr. and Mrs. William Devereaux, and Mr. and Mrs. Carl W. Haffenreffer enjoy the Narragansett Brewing Company event. (Courtesy of William Devereaux.)

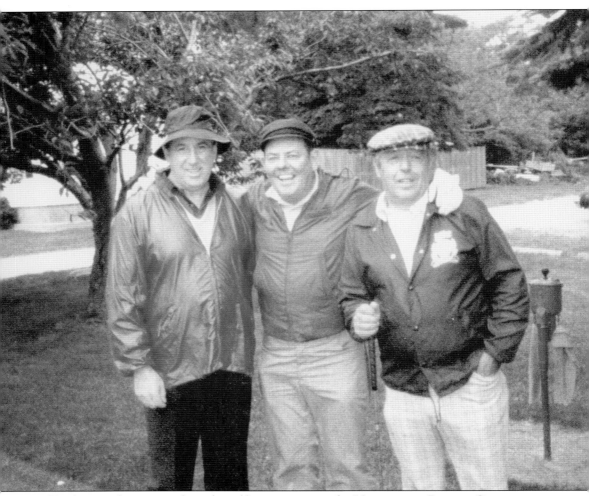

Employees take time out from the golf game to pose at this Narragansett Brewing Company event in the 1960s. William Devereaux is pictured in the center. (Courtesy of William Devereaux.)

Eight

FALSTAFF FINAL YEARS
1970–1983

Success and fame did not last very long for Narragansett beer. By the 1970s, after it was sold to Falstaff, there began a terrible decline in sales. Several reasons were given, primarily the introduction of newer and lighter beers that appealed to younger drinkers. The "sixties kids" called Narragansett beer "my father's beer," and they refused to buy it. Falstaff owners tried to promote their brand of beer. They reduced the sales personnel and stopped advertising the Narragansett brands. Eventually sales began to drop desperately. The image and popularity of the brewery began to drop as well. Workers became very disheartened with the new management and the changes in company policy. The Falstaff Brewing Company ran into financial distress in 1973 and 1974. Paul Kalmonovitz acquired control of Falstaff in the spring of 1975. He quickly implemented the practice of "undertaking" breweries that made him a $500 million specialist on the West Coast. Although still called the Narragansett Brewing Company, Falstaff was clearly in control. In 1981, the owner made a decision to close the Cranston plant and maintain control of the real estate, transferring brewing operations to Fort Wayne, Indiana. The brewery reopened for a few months in 1983, but things did not work out, so it was closed forever. Most of the former Narragansett workers were overwhelmed at suddenly being unemployed, untrainable, and unprotected by a company they had loved and supported for years. A decision was made in the summer of 1998 to demolish all the structures except for the old trolley barn. On "demolition day," October 27, 1998, former employees looked sadly on as the bulldozers went to work and turned everything into broken bricks and tons of debris. The trolley barn would fall victim to vandalism a few years later, and it would be destroyed as well. It is sad to have heard doleful stories of the retirement years of the Narragansett Brewing Company employees who once enjoyed prosperous living. Few people understood the destiny of the Narragansett Brewing Company. Many say that the demise would never have happened under the Haffenreffers. This thinking, some say, may be fallacious, for the Falstaff group kept the plant operating for over 15 years. This was not the Haffenreffers' long-term plan, or else, as other folks think, they should have taken the expansion gamble outside New England during the company's prosperous years.

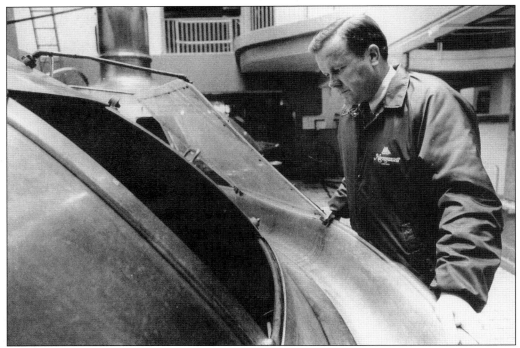

William Anderson, brewmaster, standing at the brew kettle, recalled that when he left Falstaff in 1975, it was producing at least 18 different brands of lager and ale. This was enough to give any brewmaster a headache. (Courtesy of William Anderson.)

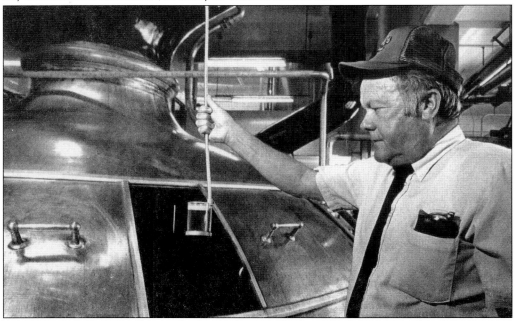

Brewmaster William Anderson checks the brew in the brew kettle at the Stroh/Schlitz brewery in Van Nuys, California, in 1986. This kept him prepared to later take over as brewmaster at the current Narragansett Brewing Company. (Courtesy of William Anderson.)

After the birth of her daughter Michelle in 1970, Betty Gordon reported being discharged with gift samples of Enfamil for baby and six bottles of Narragansett beer for the nursing mother. (Courtesy of Betty Gordon.)

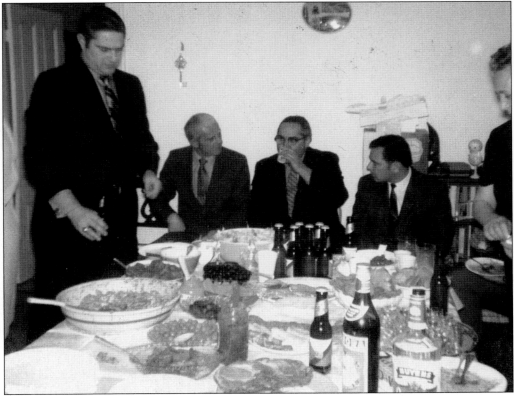

The Gordon family and friends welcome the new baby at her christening party with lots of bottles of Narragansett beer. (Courtesy of Betty Gordon.)

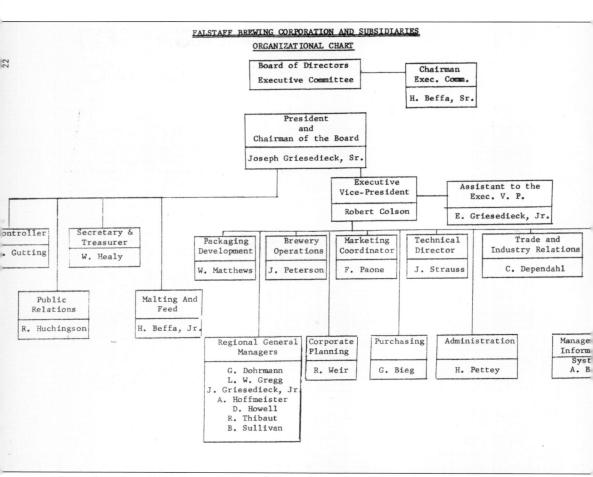

FALSTAFF BREWING CORPORATION AND SUBSIDIARIES
ORGANIZATIONAL CHART

Shown here is a Falstaff organizational chart. Falstaff announced organizational changes to address its serious problems. (Courtesy of Edmund Strauss.)

NARRAGANSETT BREWING CO.

• •

AGREEMENT WITH
International Union of
United Brewery, Flour
Cereal, Soft Drinks and
Distillery Workers of
America, A.F.L.—C.I.O.
LOCAL UNION NO. 114

Seen here are copies of the union book and constitution from September 1971. (Courtesy of Harold Nelson.)

CONSTITUTION

INTERNATIONAL UNION OF UNITED BREWERY, FLOUR CEREAL, SOFT DRINK AND DISTILLERY WORKERS OF AMERICA

INT'L UNION OF UNITED
UNION MADE
BREWERY, FLOUR, CEREAL, SOFT
DRINK and DISTILLERY WORKERS
OF AMERICA

Adopted at the
Miami Beach, Florida, Convention
September 27-30, 1971

 74

HOUSEHOLD FINANCE
Corporation of Norfolk

7510 GRANBY STREET • PHONE: 583-5201

NORFOLK, VIRGINIA 23505

August 21, 1972

Falstaff Brewing Co.
St. Louis, Mo.

Gentlemen:

.Just what you fellows have done and are doing to Falstaff
I do not know. I do know, however, there isn't a beer on the
market that can beat it. It appears to have made a vast
change in character just within months.

A pleasure to taste and a pride to serve. Many thanks for
doing whatever you did to make it this way.

Sincerely,

J.M.GROOBEY
112 Severn Rd. E.
Norfolk, Va.

Seen here is a letter from a satisfied customer that was sent to the brewmaster and the sales manager. (Courtesy of Edmund Strauss.)

Volume 13, Number 12
December, 1969

The FALSTAFF SHIELD

A Shooting
Down at Mother's Page 3

Falstaff Camera
on Campus Page 5

Our Man
in Santa Ana Page 6

Strauss New Technical Director

John Strauss

St. Louis, Mo. — John Strauss, named Falstaff's technical director Nov. 10 by President Joseph Griesedieck, brings 37 years of skill and experience to his position.

The former master brewer at the company's Cranston brewery has an "enviable past record of achievement and recognition in the brewing industry," Griesedieck said.

Strauss is responsible for all technical aspects of brewing including the process, material and formula. He also will develop other types of beer, if and when these are desirable. Another major responsibility, in conjunction with the company's training function, will be to develop programs to increase even further the level of technical competence among employees involved in brew-

University, New York, and Newark College, Newark, N.J. He is a graduate of the United States Brewers' Academy and was associated with breweries in New Jersey and Pennsylvania prior to joining Narragansett Brewing Company in 1947.

Griesedieck said Strauss' appointment lends "added emphasis to the very important matter of the product proper — beer — so that our present competitive position stands every possible chance for improvement."

William DonLevy, director of

will report to the president.

Griesedieck said the company will continue to concentrate on the quality control features and many spe-

Ft. Wayne Branch Passes Goal Line

Fort Wayne, Ind. — In the stands for the exciting Notre Dame — Air Force football game Nov. 22 was the hard-

This copy of the *Falstaff Shield* newsletter describes the promotion of John Strauss from 37 years as a brewmaster to overall technical director of all Falstaff's brewing lines. (Courtesy of Edmund Strauss.)

100

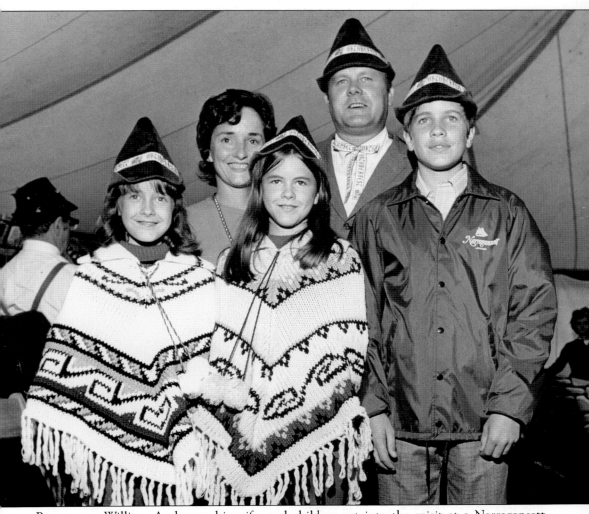

Brewmaster William Anderson, his wife, and children get into the spirit at a Narragansett Brewing Company Octoberfest. (Courtesy of William Anderson.)

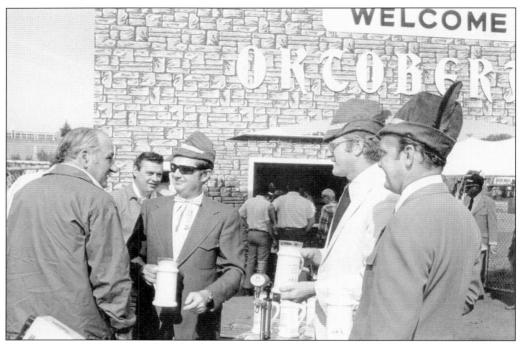

There to greet folks at the 1975 Octoberfest are, from left to right, Al Hoffmeister (in sunglasses) for Falstaff, Rhode Island lieutenant governor J. Joseph Garrahy, and Cranston mayor James Taft. (Courtesy of Vincent Garrahy.)

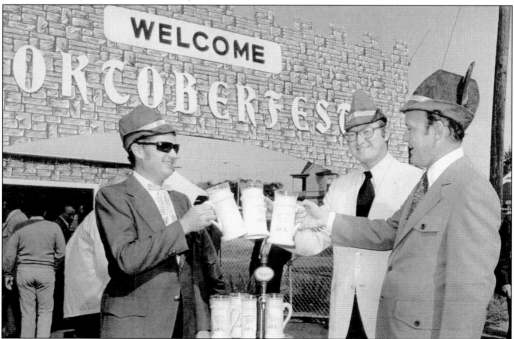

Toasting one another with souvenir steins are, from left to right, Al Hoffmeister, Lt. Gov. J. Joseph Garrahy, and Mayor James Taft. (Courtesy of Vincent Garrahy.)

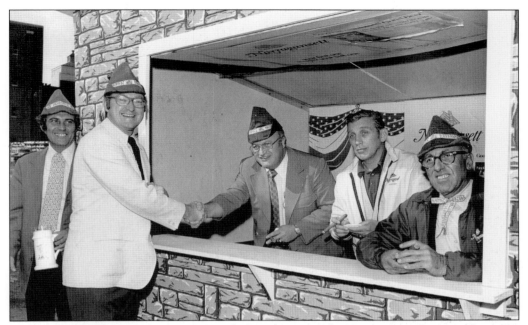

Rhode Island lieutenant governor J. Joseph Garrahy greets the Narragansett Brewing Company Octoberfest welcoming team. Seen here are, from left to right, Bill Mackie, J. Joseph Garrahy, Domenic DiFolco, Robert Baggett, and Robert Saporito. (Courtesy of Vincent Garrahy.)

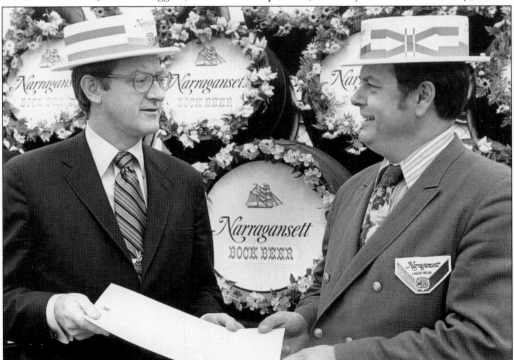

Rhode Island governor J. Joseph Garrahy is seen handing the proclamation for the Narragansett Bock Festival to Barry Sullivan of the sales department. (Courtesy of William Devereaux.)

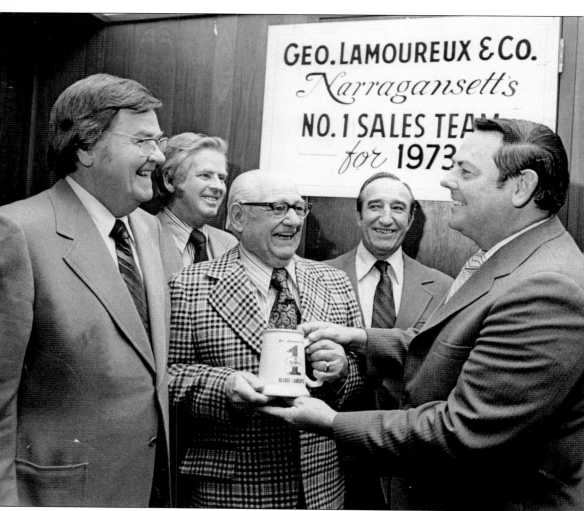

The number one sales distributor in 1973, George Lamoureux and his son (left), from Brockton, Massachusetts, accept an engraved stein from William Devereaux. (Courtesy of William Devereaux.)

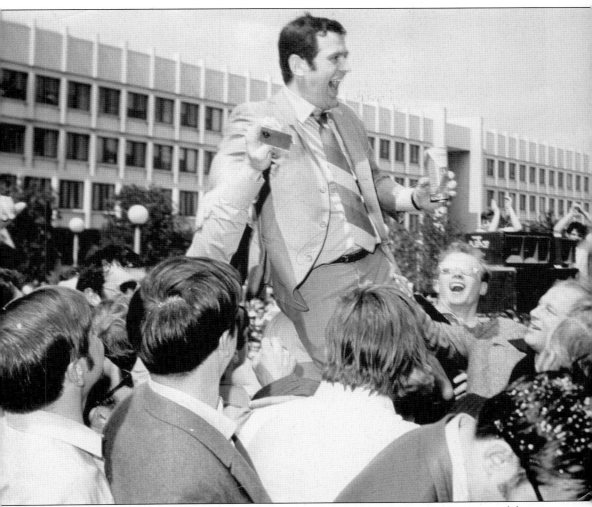

As the Boston Bruins hockey team wins the Stanley Cup, tennis celebrity Bobby Riggs celebrates above the crowd with a can of Narragansett beer. (Courtesy of William Devereaux.)

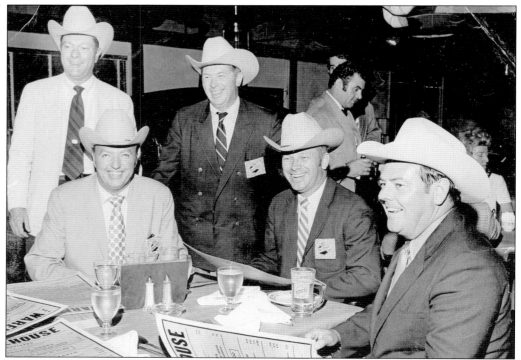

The former Narragansett Brewing Company sales team celebrates here, as the Falstaff team, with monogrammed jackets and 10-gallon cowboy hats from Texas. (Courtesy of William Devereaux.)

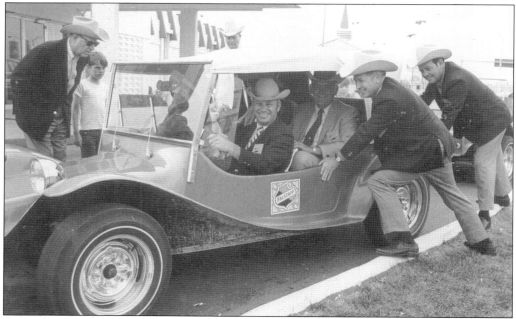

Helping to promote the Falstaff products, the sales team's car ran out of gas. (Courtesy of William Devereaux.)

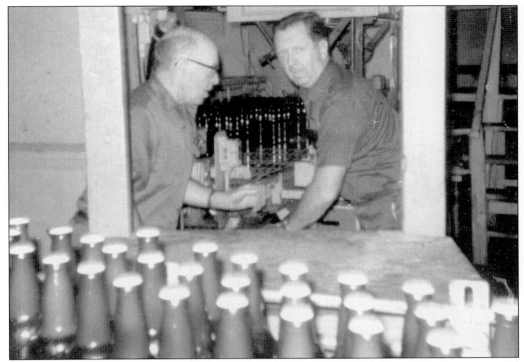

Seen here is a view of workers inside the bottling shop, working amid the various conveyors used in the bottling process. (Courtesy of Anthony Strakaluse.)

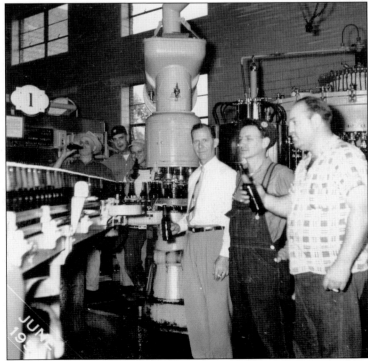

At a special event, bottle shop workers are toasting with a Narragansett beer. (Courtesy of Anthony Strakaluse.)

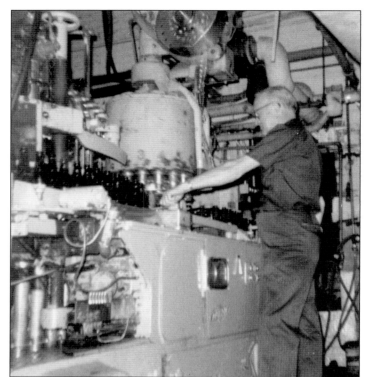

A bottle shop worker is shown at the filling machine, where clean bottles were filled with beer. From there they would go into the pasteurizer. After that process, they went via conveyor belt to be put in boxes. Then they were sent to the storage warehouse to await delivery. (Courtesy of Anthony Strakaluse.)

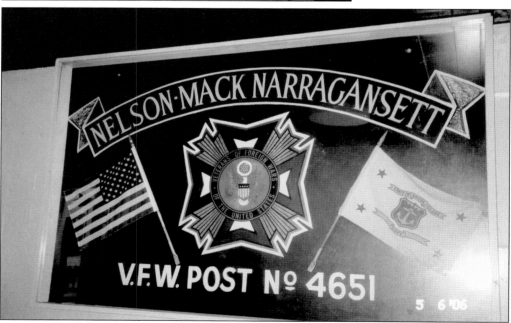

This sign at the Nelson-Mack Narragansett VFW Post in Cranston is in memory of two sons of Narragansett Brewing Company workers. The boys died in military action. The post is a short trip from the former brewery site and is used by many former workers who like to talk about their brewery days. (Photograph by Hazel B. Turley.)

Nine

NOSTALGIA AND DEMISE
1985–2005

After the official closing of the Narragansett Brewing Company Falstaff in 1983, many employees lost hope of returning to the company. Some of them had worked only in these positions for most of their lives. Many were not equipped to work at or to find other jobs. Many employees managed to maintain friendships by attending monthly meetings held at the Nelson-Mack Narragansett VFW Post in Cranston, not far from the old brewery site. Other employees found work with a local beer distributor, who had worked at the Narragansett Brewing Company, along with his father. This helped to keep friendships and loyalty together as they recovered from their collective losses. Collectors of memorabilia as well as families and friends were attracted by a story that a local woman was interested in compiling a history of the Narragansett Brewing Company. The response to her request brought calls and letters from former employees who agreed to be interviewed regarding their jobs and memories of their brewery days. Suddenly out of closets and old photograph albums emerged company memorabilia and photographs of happy events. There was very much praise for the Haffenreffer family, which the employees honored with great respect and admiration. Stories were told about the various brewmasters over the years and especially John Strauss, with his thick accent. However, the one story that was repeated so often was the one about how the employees were allowed to drink beer during working hours. Worth remembering is the one about the union representative who returned from a meeting to talk to some of his fellow workers. He said, "Well guys, you'll be happy as I just got you an extra week's vacation: six weeks for 10 years service." "No way!" they hollered back. "Why not?" he asked. Then they started to explain, "We come to work, we get some beer. We take a break, we get some beer. We eat lunch, we get some beer. We take a break, we get some beer. Five days a week! We can't afford to stay home for a week and miss all that free beer!" It seemed that every employee had his or her brewery story or joke. By retelling it to others, it helped to relieve the sadness each felt when the Narragansett Brewing Company finally closed.

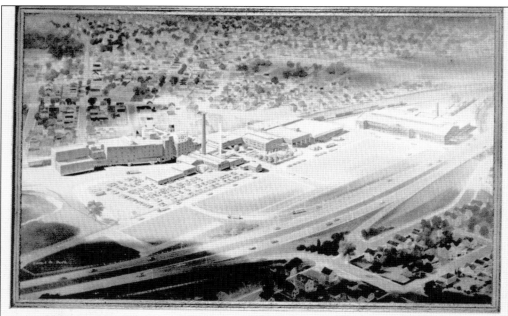

THE HOME OF THE LARGEST SELLING BEER IN NEW ENGLAND

Hi, neighbor—have a 'Gansett! Enjoy the refreshing straight-from-the-barrel taste that only light, bright Narragansett Lager Beer gives you. At home, at the ball park, or at your favorite tavern— whenever or wherever you watch the Red Sox play—have a 'Gansett. It's a natural with the grand old game.

YOUR RED SOX RADIO AND TELEVISION HOST FOR THE 20TH STRAIGHT YEAR

A 1965 Narragansett advertisement featured on the back of a 1965 Red Sox yearbook is pictured here. (Courtesy of Ed and Greg Theberge collection.)

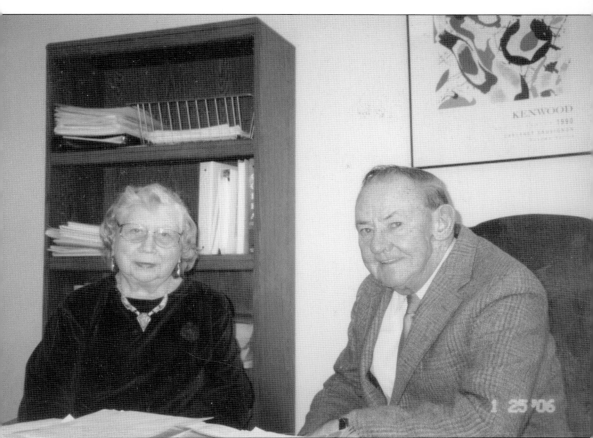

Virginia Schneider and William Devereaux maintain a very long friendship, which began at Narragansett Brewing Company. As they continue to work for a former employee, they share many memories of their brewery days. Schneider worked as secretary to William Considine Sr., and Devereaux also worked with him in the sales department. (Photograph by Hazel B. Turley.)

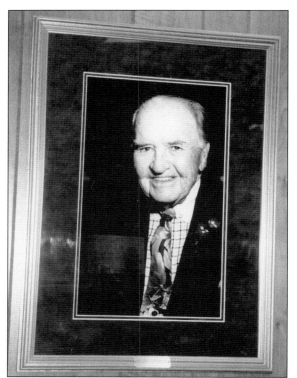

A photograph of William Considine Sr. is proudly displayed at the family's distributing business in Cranston. (Photograph by Hazel B. Turley.)

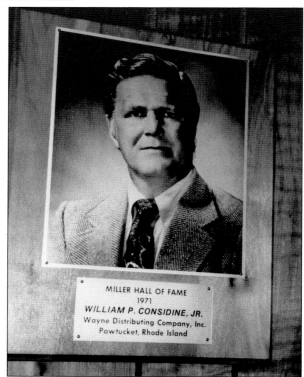

MILLER HALL OF FAME
1971
WILLIAM P. CONSIDINE, JR.
Wayne Distributing Company, Inc.
Pawtucket, Rhode Island

A photograph of William Considine Jr., who also worked with his father, is proudly displayed in Cranston. (Photograph by Hazel B. Turley.)

The former brew house stands in ruins as "demolition day" approaches. Sights such as this brought sadness as well as anger to former employees as they drove by. (Courtesy of Anthony Strakaluse.)

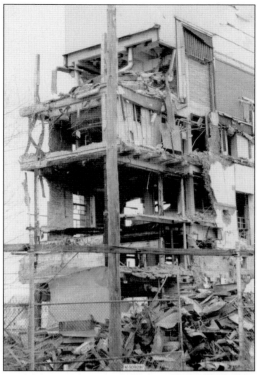

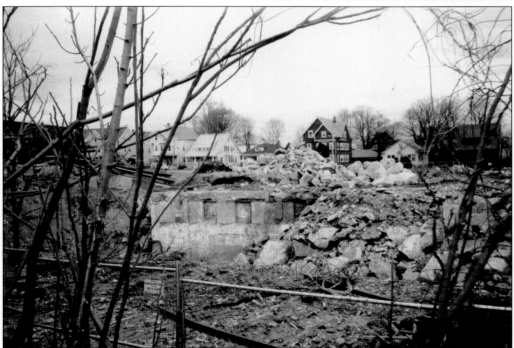

In the distance one can see the neighborhood homes that had to endure the sight of the decaying Narragansett Brewing Company buildings for many years. (Courtesy of Anthony Strakaluse.)

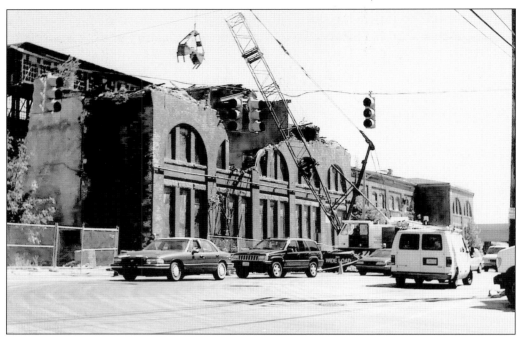

After being vandalized and set on fire, the historic trolley barn, used as a Narragansett Brewing Company warehouse, is shown as it is about to be demolished. (Courtesy of Anthony Strakaluse.)

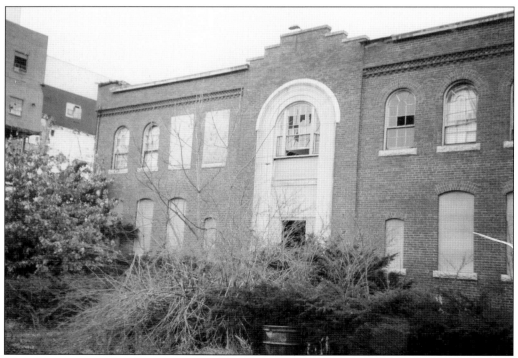

The administration building, as seen in this 1998 photograph, was included in the vandalism as well. (Photograph by Hazel B. Turley.)

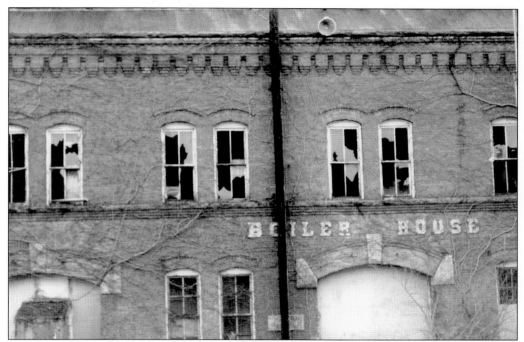

The historic Narragansett Brewing Company boiler house appeared to have every window smashed by vandals, or possibly by disgruntled customers and employees. It was very close to a busy street, so it was an easy target for those who wanted to send a message to the former owners. (Photograph by Hazel B. Turley.)

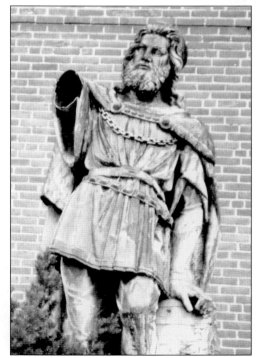

During the demise, the time-honored statue of Gambrinius lost the arm that was raised in a toast to all. (Photograph by Hazel B. Turley.)

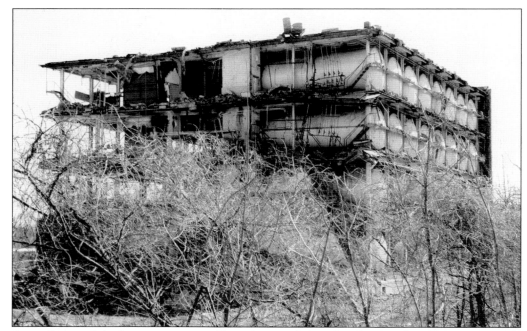

A small part of the brewery site was able to be recycled as the glass-lined tanks were in usable condition. The tanks were removed and then sent to China. (Courtesy of Anthony Strakaluse.)

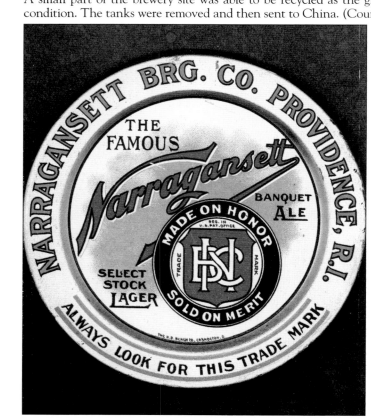

This beautiful early-20th-century tip tray advertises Narragansett Banquet Ale and Select Stock Lager. Trays such as these were used in taverns and other establishments so that patrons could leave a gratuity for prompt and courteous service. (Courtesy of Christine Richard; photograph by Emmet E. Turley.)

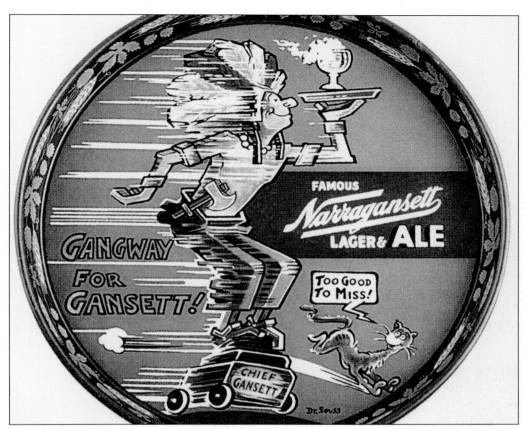

This Dr. Seuss tray delighted folks in the 1940s as it represented Rudolph F. Haffenreffer III's interests in Native Americans along with Narragansett beer. Dr. Seuss went to college with Haffenreffer's sons. (Courtesy of Ed and Greg Theberge collection.)

This 1930s wooden box was used for returnable bottles. (Courtesy of Anthony Martinelli.)

This piece of memorabilia is a replica of a Narragansett Brewing Company beer barrel and contains an AM radio. It is displayed amid a beer can collection. (Courtesy of Robert Picchione.)

Pictured here are two antique Narragansett trays with an old can of beer in a garden setting. (Courtesy of Mark Hilldebrandt.)

Ten

THE NEXT CHAPTER

Three generations of 'Gansett drinkers pose at the American Legion Post No. 10 in East Providence. Joe Ianeire, brewery employee for over 30 years, is flanked by Matt Conroy, current Narragansett beer goodwill man, and Tony Bevalaqua from the Legion post. (Courtesy of Mark Hellendrung.)

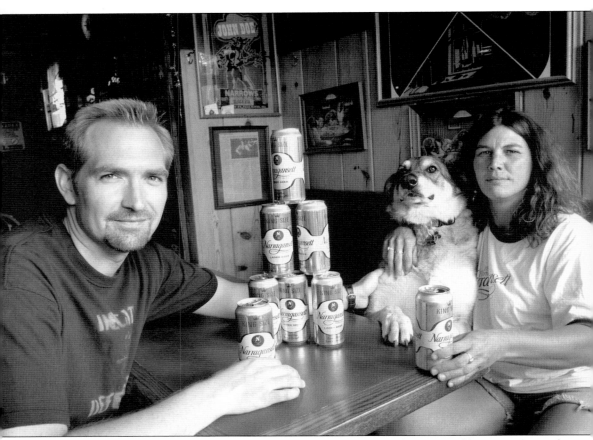

Mark Hellendrung of the Narragansett Brewing Company visits with Joann Seddon, one of several New Englanders who kept Narragansett beer alive over the years. She and her patrons eschewed the mass-marketed mega brands for Narragansett beer. Her bar, once the legendary home of Providence bookmakers, is now the place on the west side of Providence to enjoy a Narragansett with the neighborhood and root for the Red Sox. (Courtesy of Mark Hellendrung.)

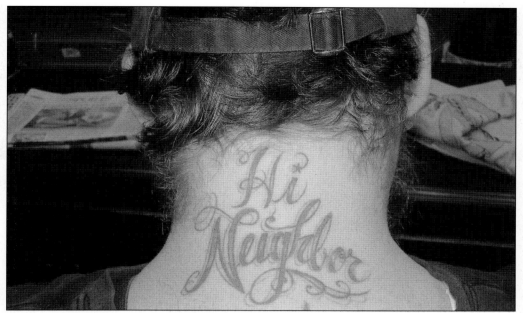

Bob Goulding, a tattoo artist with Federal Hill Tattoo in Providence, has always been a collector of everything Rhode Island. He was born, raised, and still lives in the historic village of Pawtuxet. It was there in 1772 where Rhode Islanders set fire to the HMS *Gaspee*, recognized as the first overt action leading up to the Revolutionary War. Goulding has an abundant collection of Narragansett beer memorabilia. He tattooed "Hi Neighbor" on the back of his neck about a year before the relaunch of the beer. (Courtesy of Mark Hellendrung.)

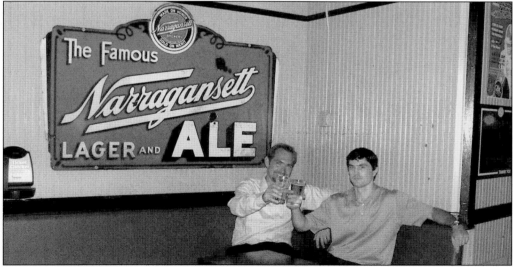

Mark Hellendrung (left) and Jim Crooks celebrate the first Narragansett draft in decades sitting under an old Narragansett sign at the Fish Company in Providence in September 2005. This large metal sign reportedly hung from the gate where vehicles entered the brewery grounds. Many bars still have Narragansett beer advertising signage from the 1950s, 1960s, and 1970s. The signage remained for years as nostalgic bar art and now once again is used to advertise Narragansett beer. (Courtesy of Mark Hellendrung.)

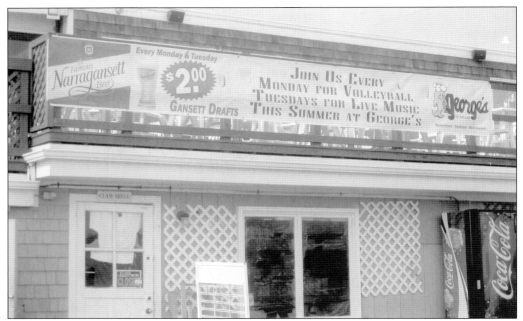

George's of Galilee is the starting and ending point for most tourists and Rhode Islanders on their pilgrimages to Block Island. George's also hosts a summer volleyball tournament for local bars. It is always a great Monday night for the locals to hang out on the beach and enjoy the sunset, smell the fresh sea air, watch the ferry, and spike some Narragansett beach balls. (Courtesy of Mark Hellendrung.)

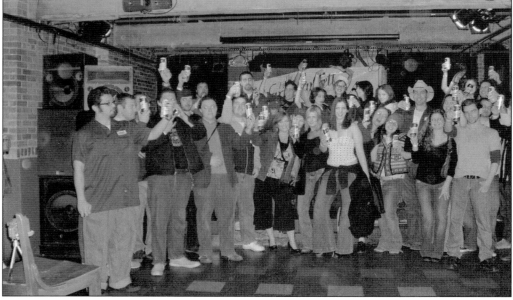

The next generation of 'Gansett aficionados, most of these partygoers are grandchildren of people that worked at the site in Cranston. Most come to events and tell stories about their family and living with the mystique of Narragansett beer. Now they can finally have their own memories. (Courtesy of Mark Hellendrung.)

This is the new way to wrap holiday gifts: "Buy a 12-pack, get 'Gansett wrapping paper." (Courtesy of Mark Hellendrung.)

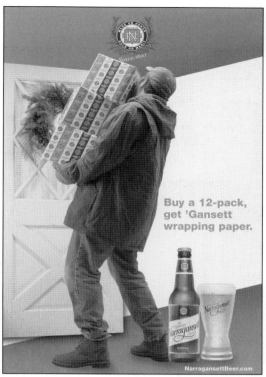

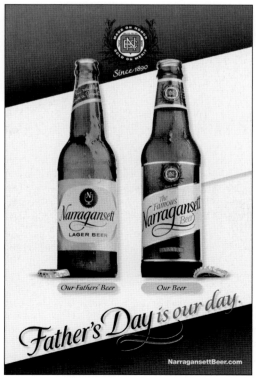

This advertisement proudly claims Father's Day as the holiday of Narragansett beer. (Courtesy of Mark Hellendrung.)

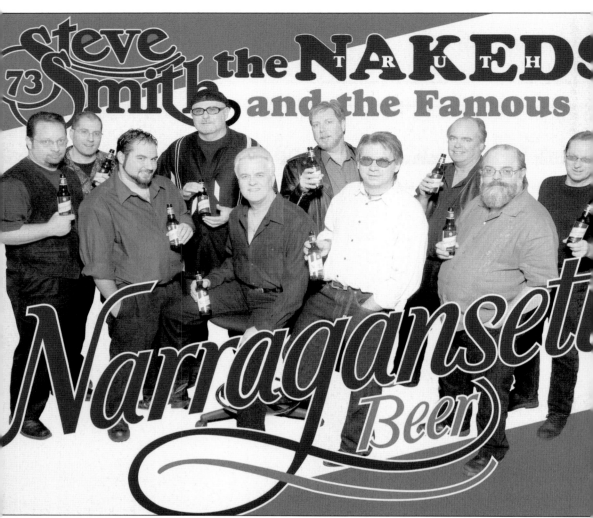

Steve Smith has been drinking 'Gansetts since his college hockey days at Providence College in the 1970s. He later formed his band, Steve Smith and the Nakeds, promoting Narragansett beer throughout New England. Once again, his band and many others are playing great music and drinking Narragansett at packed venues. (Courtesy of Mark Hellendrung.)

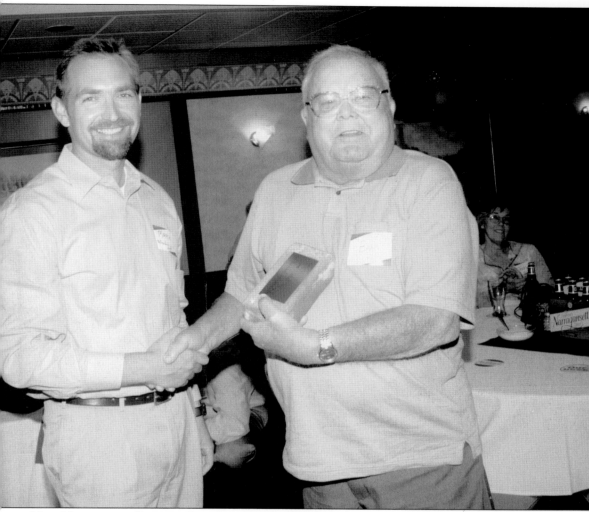

Here Narragansett Brewing Company president Mark Hellendrung is awarding master brewer William Anderson with an honorary brick from the original brewery. Anderson was master brewer at Narragansett in the 1960s and 1970s and was instrumental in re-creating the original recipe with Hellendrung. (Courtesy of Mark Hellendrung.)

10/08/2006 03:26 pm

Octoberfests have been a tradition in New England for years. William Anderson helped to create an Octoberfest beer specifically for this event at the Newport Yachting Center. Bocktoberfest is actually the marriage of two Narragansett beer traditions—Octoberfest and a bock beer. The beer is Narragansett's Heritage Bock, mastered by master brewer Anderson since 1956. It is a lager brewed with three types of malt for a touch of sweetness and a rich amber color. It is lightly hopped with two types of hops to produce a rich, flavorful, yet very drinkable lager beer in the tradition of Narragansett beer styles since 1890. (Courtesy of Mark Hellendrung.)

Pictured here is Halloween 2006 in Narragansett at Charlie O's Tavern, which showcased a six pack of walking and talking Narragansett tall boys. (Courtesy of Mark Hellendrung.)

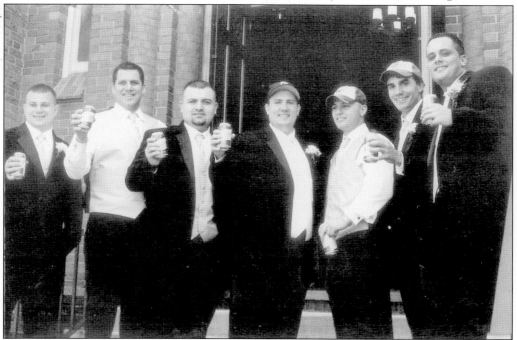

There is no better way to toast nuptials in New England than with Narragansett beer. These are the groom and groomsmen at the wedding of John Zolli to Rebecca Tropea on July 1, 2006, in Rhode Island. (Courtesy of Mark Hellendrung.)

ACROSS AMERICA, PEOPLE ARE DISCOVERING SOMETHING WONDERFUL. *THEIR HERITAGE.*

Arcadia Publishing is the leading local history publisher in the United States. With more than 3,000 titles in print and hundreds of new titles released every year, Arcadia has extensive specialized experience chronicling the history of communities and celebrating America's hidden stories, bringing to life the people, places, and events from the past. To discover the history of other communities across the nation, please visit:

www.arcadiapublishing.com

Customized search tools allow you to find regional history books about the town where you grew up, the cities where your friends and family live, the town where your parents met, or even that retirement spot you've been dreaming about.

MAP SEARCH